POSTCARD HISTORY SERIES

Santa Ana

in Vintage Postcards

POSTCARD HISTORY SERIES

Santa Ana

IN VINTAGE POSTCARDS

Guy D. Ball

Luis Arciniaga
Best wishes!
Guy Ball

ARCADIA

Published by Arcadia Publishing,
an imprint of Tempus Publishing, Inc.
3047 N. Lincoln Ave., Suite 410
Chicago, IL 60657

Printed in Great Britain.

Library of Congress Catalog Card Number: 00-108055

For all general information contact Arcadia Publishing at:
Telephone 843-853-2070
Fax 843-853-0044
E-Mail sales@arcadiapublishing.com

For customer service and orders:
Toll-Free 1-888-313-2665

Visit us on the internet at http://www.arcadiapublishing.com

CONTENTS

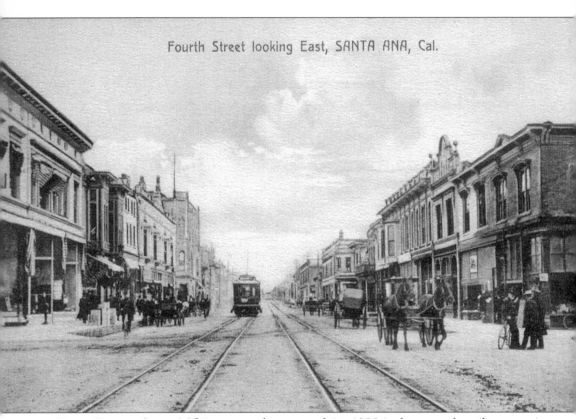

Fourth Street looking East, SANTA ANA, Cal.

EARLY FOURTH STREET! This very early postcard (*c.* 1900s) shows early rail car service running down Fourth Street, which was the business hub of the town. Note that horse and buggy, as well as walking, were the main modes of travel in those days.

INTRODUCTION

Santa Ana's rich heritage easily stretches back well before 1869, when William ("Uncle Billy") Spurgeon and Major Ward Bradford purchased the 74 acres (from Jacob Ross Sr.) that they would shepherd into the city of Santa Ana. Before that time, you had the pioneering families of Yorba, Peralta, Grijalva, and Bates—all early residents who created a living out of the hot and rugged countryside.

Throughout the late 1800s and early 1900s, Santa Ana had many, many active residents who grew the town into a large, bustling city that became prominent in commerce, government, religion, and architecture. Meanwhile, these pioneers were also making a wonderful home for residents of the new county called Orange. For the longest time, Santa Ana was the home of the region's well-to-do, in addition to offering excellent housing for residents of all ages, races, and financial conditions.

In many ways, the city has not changed. The residents and business people are among the county's most industrious and have a "can-do" positive attitude. The city government is known for its innovation in trying new things—be it the birth of an artists' village or the growth and prospering of its neighborhood movement. And Santa Ana has done a wonderful job in honoring its past with a classic downtown and vintage (and well-preserved) housing stock. (And much of that effort was thanks to neighborhood activists taking a stand!)

I'm proud to count many of its inhabitants as friends. The city befriended me—a New Jersey transplant—a number of years ago. And in time I understood its charms and the drive of the people within it. Today, even though I live just outside its borders, Santa Ana's siren song still lures me back.

I thank many people for their help in this book. The first is Diann Marsh, author of *Santa Ana, An Illustrated History*. Way back when we were in the neighborhood movement together, she asked me to become a board member of the Santa Ana Historical Preservation Society (SAHPS). I wasn't much of a history buff then but she knew I would be interested. She was right. Twelve years later, I am still with the organization and I have enjoyed helping preserve and celebrate Santa Ana history.

Rob Richardson gets the number one billing for directly helping with this book. His postcard collection was in my mind when I accepted this project. He graciously offered up his collection and then helped with information for virtually all of the cards in this book. An amazing feat for a very, very busy man. Thanks!

I had help from a few other Santa Ana card collectors. In the process, I met some great Santa Ana residents who collected cards because of the pride they have in the city in which they live. One even buys especially unique cards off the Ebay auction site to keep them local and to avoid out-of-staters from getting them.

So I want to thank the following: Brett Franklin, a long-time resident (and friendly card competitor of Rob's); Nathan and Roberta Reed, a couple who have always had strong family ties to the city and stay active in Santa Ana historic and neighborhood preservation; Frank Ramirez, another proud local boy who still runs the family business on the outskirts of downtown Santa Ana; Jeff Dickman, a newer resident of the Historic French Park Neighborhood who celebrates the city's history by collecting cards; Ginelle Hardy, a leader in the historic Heninger Park Neighborhood, who helped with details regarding cards depicting her neighborhood; and Frankie Mosher, who wanted to ensure that her Santa Ana relatives were remembered.

A big thanks to Steve and Catherine Cate who initially helped me with encouragement and ideas. Their love for the city and its past drew them more and more into the project. They provided me with last-minute editing help and helped me create wonderful captions when I began to run out of steam.

Thanks to Tom Lutz, another long-time resident, who took time out of his busy schedule and researched some of the cards with his family. And thanks to fellow SAHPS board member Patty Haines who reviewed the captions and contributed additional background information.

If I might be so bold, I also want to thank two others who helped shape my interest and activism with Santa Ana. Dee Runnells was a neighbor and a concerned resident who always spoke her mind and worked to change things for the better. She was the key person to get me involved in my community. When I would rather watch *Starsky and Hutch* reruns, she encouraged me to attend Wilshire Square neighborhood meetings. Fortunately for me, she eventually succeeded.

And thanks to City Manager Dave Ream who deserves way more credit than he gets for the growth of the neighborhood movement and the downtown artists village—two things that have helped turn the city around. His behind-the-scenes work in these and scores of other projects is never really apparent unless you look closely. But his support was always crucial.

I need to mention Nicholas and Alexander, my little czars, who occasionally join me in projects at the Dr. Willella Howe-Waffle House and now feel at home at the "Waffle House," as they call it. I know the spirit of Dr. Willella enjoys and appreciates having children back in the house.

Lastly, this book would never have happened without the amazing support of my wife, Linda. She has been tremendously accommodating these last few months in giving me the time and space to complete this project—knowing how important it was to me. Thank you again for your help, support, and love.

So, readers, please enjoy the book. Let's remember those who came before us, celebrating what they did and what remains from their dreams and labors.

And in celebrating the past, we are truly preserving it.

Guy Ball
December, 2000

One
Santa Ana's Gold

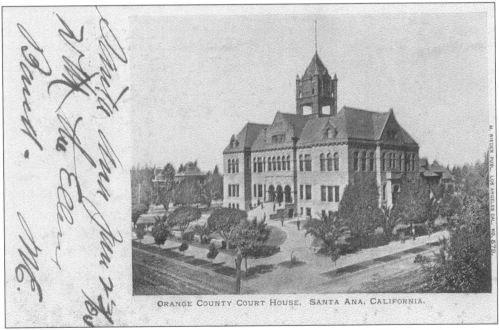

ORANGE COUNTY COURT HOUSE, SANTA ANA, CALIFORNIA.

ORANGE COUNTY COURTHOUSE. This landmark courthouse at 211 West Santa Ana Boulevard is Southern California's oldest court building. Built in 1901, this granite and sandstone building was designed to be the most impressive building in early-20th century Orange County. Today, the 30,000-square-foot building has been restored to look much as it had at the turn of the last century. In 2001, the courthouse will host a variety of centennial celebrations.

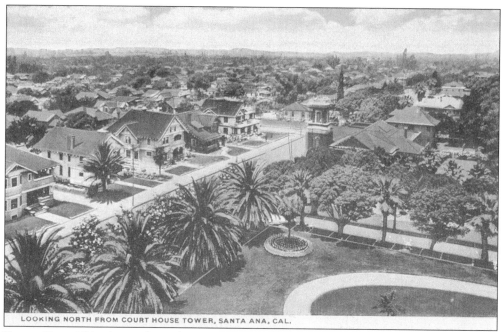

LOOKING NORTH FROM COURT HOUSE TOWER, SANTA ANA, CAL.

TOWER VIEW. This view is from the Orange County Courthouse looking to the northwest (towards Eighth Street). Homes to the left faced Broadway. The Spurgeon Memorial M.E. Church is located to the right. When the church was relocated to new quarters, the old sanctuary was used as a courtroom until the "new" county courthouse was built in 1966. The building was torn down to enable construction of Civic Center Drive.

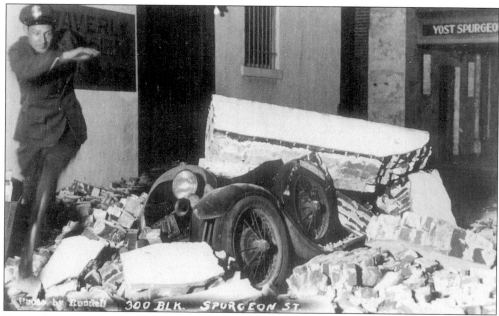

EARLY COMPACT(ED) CAR. This crushed car parked in the 300 block of North Spurgeon Street suffered damage from a falling building facade due to the Long Beach earthquake on March 10, 1933. The Yost Theater is just beyond the alley way.

10

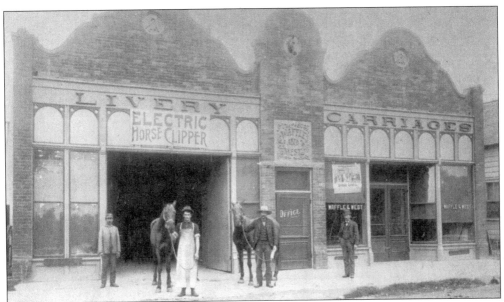

WAFFLE AND WEST LIVERY (*c.* **1901**). Located at 417 and 419 West Fourth Street, this large livery stable was owned by Edson Waffle and Charles West. Livery stables played a large role in the days before automobiles took over, renting out horses and buggies to those who didn't have them. Edson was the second husband of Dr. Willella Howe-Waffle.

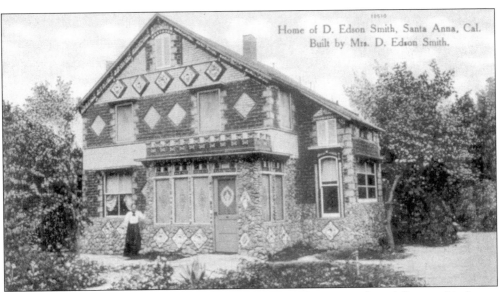

THE SMITH HOME (1909). With the exception of the frame, roof, and floors, this home was built by hand by Ellen Frances Smith (Mrs. D. Edson Smith), depicted in the picture as a spry and healthy 70 year old. The card notes that the outside "consisted of cobblestones, seashells, imitation brick, and galvanized iron, and was covered with a preparation of abalone sand of her own devising, pulverized glass, sanded wood, painted glass pictures here and there, inlaid with queer bits of ancient and modern bric-a-brac that nobody else ever found use for."

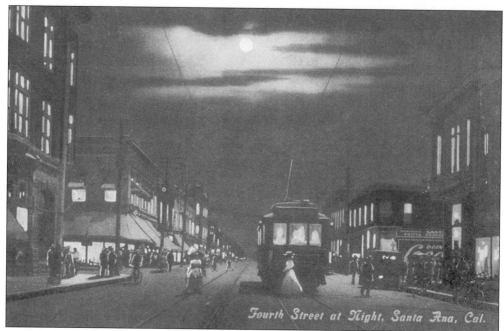

FOURTH STREET AT NIGHT. Residents enjoying a pleasant evening out on the town are pictured on Fourth Street at Main looking east, *c.* 1907. Notice the manner of dress, the Pacific Electric car, and abundant nightlife in the business and civic center of Santa Ana.

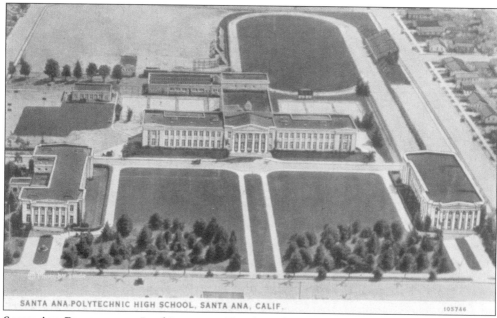

SANTA ANA POLYTECHNIC. Looking more like the White House, this high-tech school was built in 1912–13, and stood basically where the present-day Santa Ana High School is located. At the time, the building and the teaching facilities were considered "ahead of its time," and the facility was considered one of the best in the entire Southern California region.

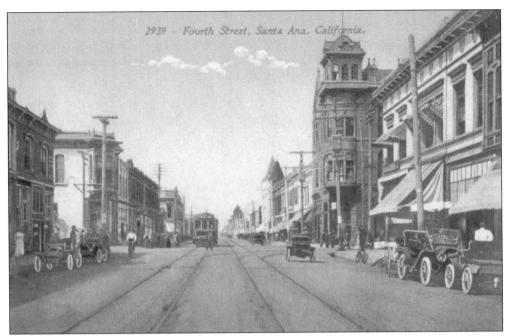

FOURTH STREET. This image is a view of Fourth Street *c.* 1910 as you look west from a position just east of Main Street. The taller building on the right side, about midway down, is the First National Bank Building. Note the Pacific Electric car and the "late model" cars.

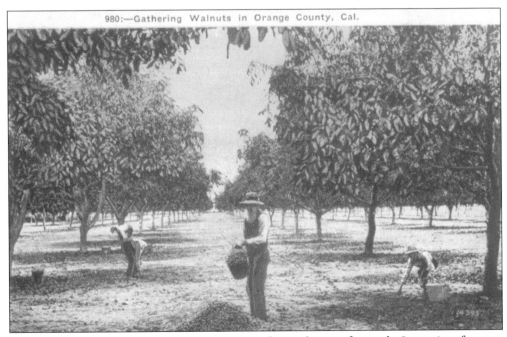

980:—Gathering Walnuts in Orange County, Cal.

GATHERING WALNUTS. The walnut was a popular cash crop for early Santa Ana farmers and other property owners with groves located on the outer parts of the city. Eventually, the trees were removed to make way for houses.

13

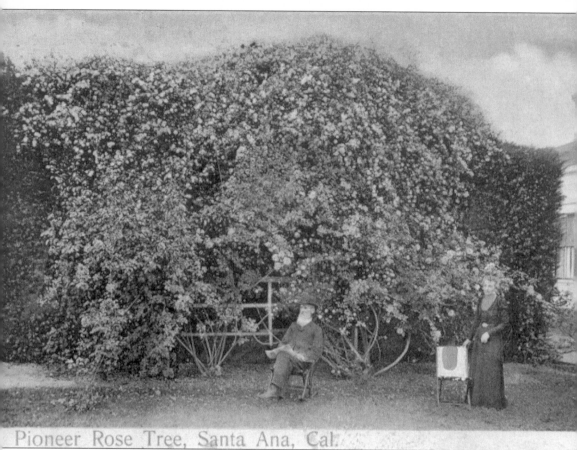

Pioneer Rose Tree, Santa Ana, Cal.

PIONEER ROSE TREE. It was around 1910 when William F. Spurgeon and his wife, Jennie, posed beside this magnificent rose bush at their home on East Fourth Street. About 40 years had passed since he purchased the original 74.25 acres from Jacob Ross in 1869. During that time he had been appointed the town's first postmaster and had served as a storekeeper, mayor, alderman, and marshal. At his own expense he had cut a 3-mile-long road through the mustard grass so that the stage company could serve Santa Ana. The town was served by the railroad, the red car, telephones, gas, and electricity—voters elected Santa Ana the county seat in 1889. Spurgeon had lived to see his dream take root and thrive.

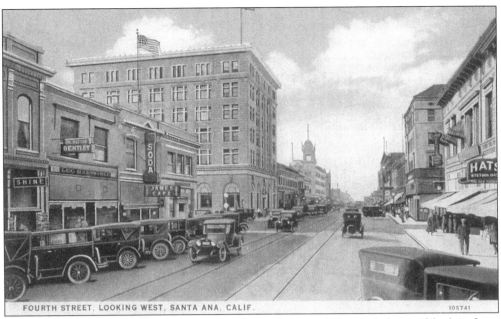

FOURTH STREET, LOOKING WEST, SANTA ANA, CALIF. 105741

FOURTH STREET, LOOKING WEST. This view of Fourth Street is located about a block in from Main, looking towards the west. Notice the variety of shops and restaurants and the tracks for the Pacific Red Car. The tall building in the middle on the left side is the second First National Bank building, built in 1923, and at the time, Santa Ana's tallest building.

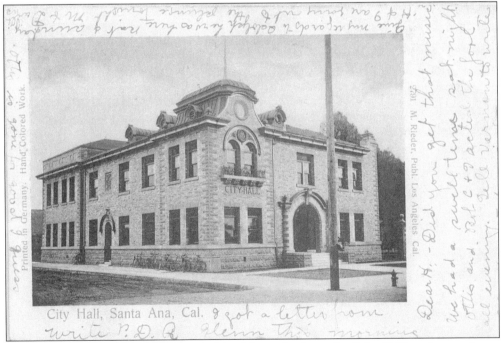

City Hall, Santa Ana, Cal.

CITY HALL. This is the original city hall building which was built in 1903 at the southeast corner of Main and Third Streets. It was used until 1935, when it was replaced with a bigger building to handle the city's growing population and government.

15

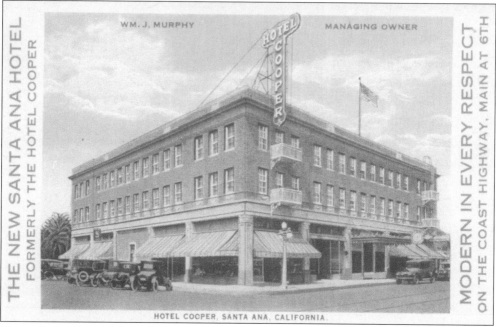

HOTEL SANTA ANA. Built in 1922, this hotel was located in the center of the business and civic districts at the corner of Main and Sixth Streets. At one time it was known as the Hotel Cooper. In the 1920s, rooms cost between $1.50 and $2.50 a day. The building was demolished in the mid-1980s.

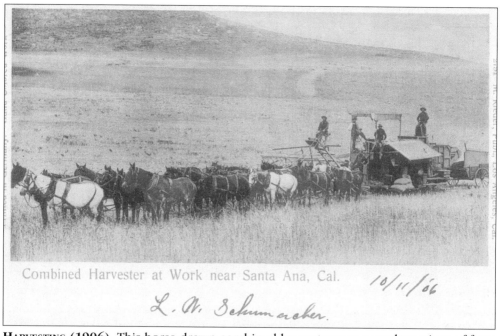

Combined Harvester at Work near Santa Ana, Cal.

10/11/06

L. W. Schumacher.

HARVESTING (1906). This horse-drawn combined harvester was a modern piece of farm gear at the turn of the century. It was very efficient for the time.

Two
DOWNTOWN SCENES
AND THE ORANGE COUNTY
COURTHOUSE

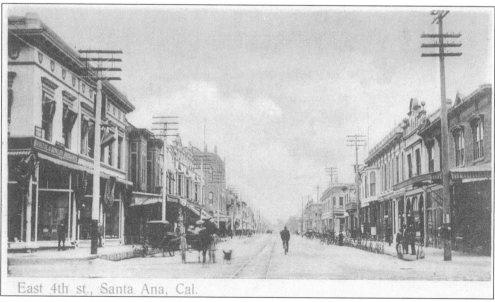

East 4th st., Santa Ana, Cal.

EAST FOURTH STREET. This is a view of the East Fourth Street businesses from Main Street. The tall building midway down the block on the left side is the Grand Opera House, built in 1890. Note the trolley tracks in the street and the electrical poles at the curbs. In the distance on the right, you might be able to see a few of the first automobiles that graced the dirt roads of Santa Ana. Otherwise, popular transportation included walking, bicycle, horse and buggy, and the street railway.

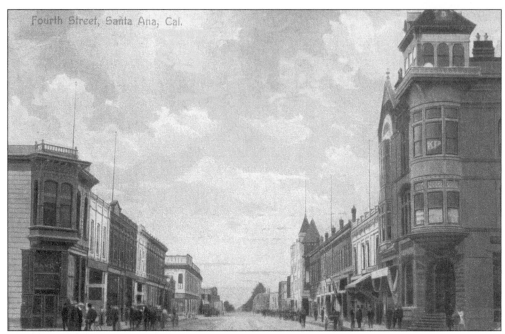

WEST FOURTH STREET (*C.* **1900**). This view of Fourth Street at the turn-of-the-century is looking west from Main Street. The older First National Bank building is on the immediate right. The Hotel Rossmore is the tall building down the block on the right side. The Commercial Bank is located on the far left. Also on the left, one block further, is the second Spurgeon Building (built in 1882).

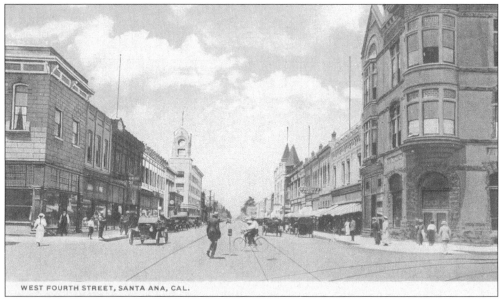

WEST FOURTH STREET (*c.* **1920**). This is a great view of Fourth Street a few years later than above. You can see some big changes—the third Spurgeon Building was built in 1913 and is on the left side in the distance. Also note the Pacific Electric tracks in the center of the street. The line arrived in Santa Ana in 1905 and sped passengers to Los Angeles via Watts.

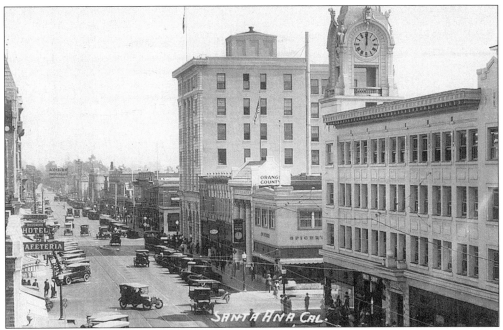

WEST FOURTH STREET, LOOKING EAST. This crisp 1920s view looks east on Fourth Street from a position at about the mid-200 block of West Fourth. The Spurgeon Building dominates the view, but the tall building in the middle is the First National Bank building.

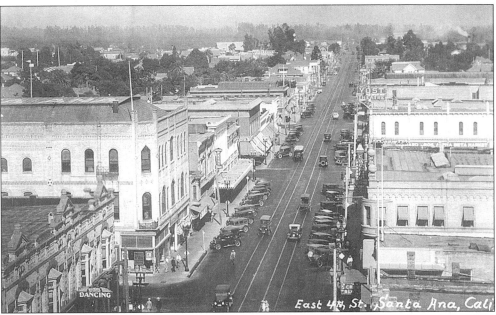

EAST FOURTH STREET. This view looks to the east from the First National Bank building at Fourth and Main Streets. Note the stands of eucalyptus trees as windbreaks for orchards on the far horizon. A close look at the right center reveals a sign for the Alpha Beta Market (at Spurgeon), which was headquartered in Santa Ana for a time.

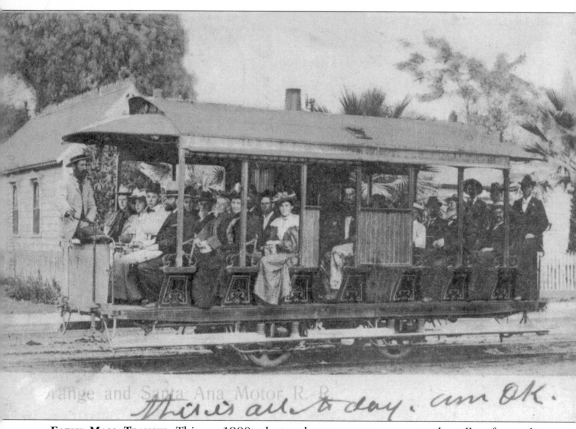

EARLY MASS TRANSIT. This *c.* 1900 photo shows a steam-powered trolley from the Orange and Santa Ana Motor Railway transporting passengers into Santa Ana (nicknamed the Orange "Dummy"). Earlier street line railways included horse-pulled cars and date back to 1886, with the creation of the Santa Ana, Orange, and Tustin Street Railway Company. The original horsecar barn was located on West Fourth Street. Street railways carried people to Olive Street in Orange and the Southern Pacific Depot on Fruit Street in Santa Ana. One humorous story even noted that while the horses and mules would be needed to pull the heavy carts up a hill on the outskirts of Orange, the animals would sit on the trolley for the return downhill trip, enjoying a pleasant ride past picturesque countrysides. Horses were generally replaced with steam-powered cars by 1896. These local systems were replaced in 1905–06 with the new Pacific Electric Red Cars that traveled to Los Angeles.

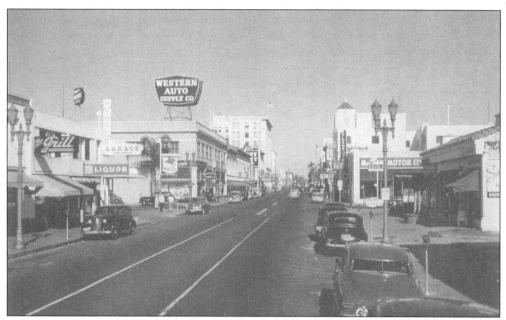

MAIN STREET. This is a view as you look north up Main Street, just past First Street, *c.* 1955. Note the Western Auto Supply store and the tall First Western Bank building (as you near Fourth Street) on the left side, and city hall on the opposite side.

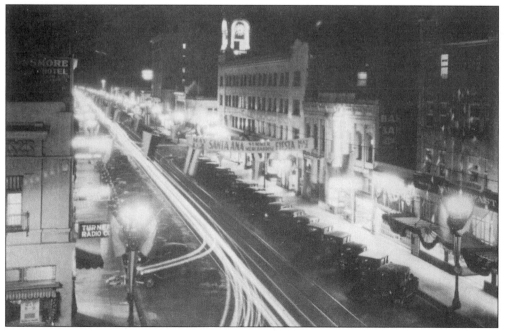

SUMMER NIGHT. This exceptional nighttime view of Fourth Street looks east from Broadway. Note the wonderful lighting of the Spurgeon Building's clock tower. This 1930s photo was taken by noted local photographer Edward Cochems, father of Adeline Walker.

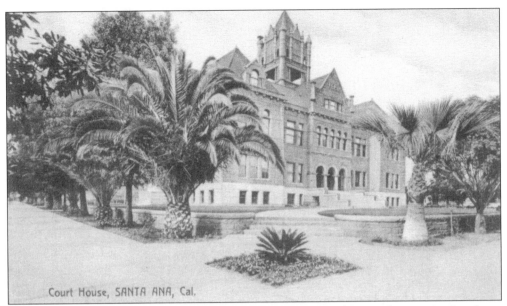

Court House, SANTA ANA, Cal.

ORANGE COUNTY COURTHOUSE (C. 1910). This landmark courthouse is Southern California's oldest court building and one of the few remaining buildings in the Richardsonian Romanesque Revival style. Dedicated in November of 1901, the building took 17 months to build. It was designed by Curtis L. Strange of Los Angeles.

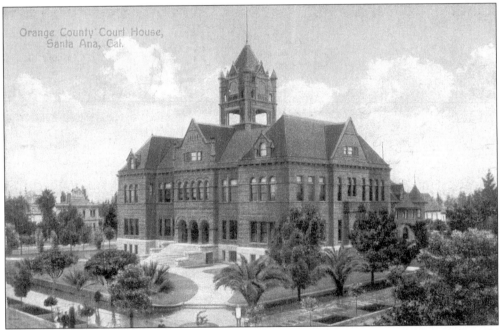

Orange County Court House,
Santa Ana, Cal.

ORANGE COUNTY COURTHOUSE (C. 1906). In this view, you can see a little of the Old County Jail to the rear of the courthouse. The jail was facetiously known as Lacy's Hotel, for then County Sheriff Theo Lacy; his son, Budge, who was the jailer; and his wife Nona, who was the jail matron. The jail was demolished in 1924, but its footprint has been outlined in brick in the center of the parking lot behind the courthouse .

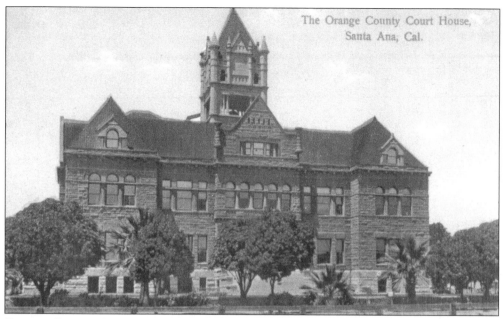

ORANGE COUNTY COURTHOUSE (*c. 1920s*). In this view you can see the wonderful tower on top of the building. It was removed after the 1933 earthquake due to some structural damage. The total cost to build the courthouse in 1900–01 was $117,000. The contractors were Chris McNeill and J. Willis Blee. The sandstone veneer was brought in from Arizona.

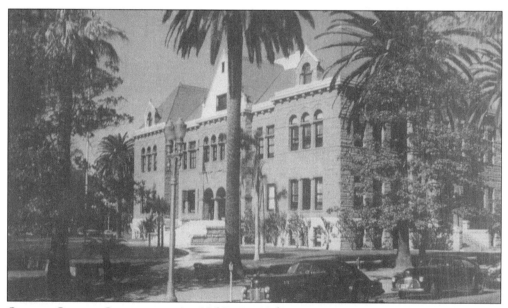

ORANGE COUNTY COURTHOUSE (*c. 1950*). In 1968, a new county courthouse was built, essentially retiring this one from court service. The building was determined to be seismically unsafe in 1979 and closed down. After a few years of research, the county decided to restore the grand old building. In November of 1987, a multi-million dollar restoration project began, with work finally completed in 1992.

23

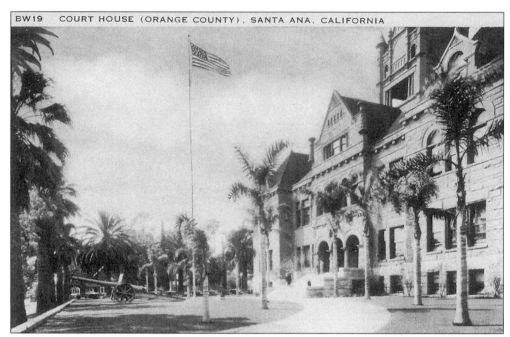

ORANGE COUNTY COURTHOUSE (c. 1930). This view is from Sycamore looking west. On the other side of the courthouse, on Broadway, the First Christian Church was located on the left and St. Ann's Inn on the right.

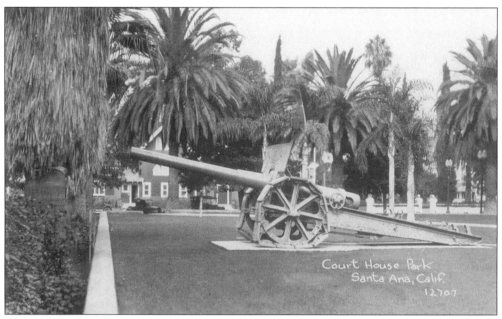

COURTHOUSE CANNON. This World War I field cannon is on the front lawn of the county courthouse. It was added in 1925, replacing a Civil War cannon which was moved to Irvine Regional Park. During WW II metal scrap drives, this cannon was melted down for reuse. Today, two other cannons (from WW I and WW II) reside on the courthouse lawn.

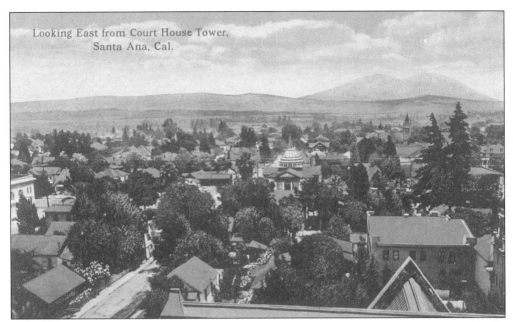

EAST VIEW FROM COURTHOUSE (c. 1915). In the center, you can see the dome of the First Congregational Church and the spire of the Episcopal Church on Seventh between Main and Bush Streets. To the left center is the First Baptist Church at Eighth and Main Streets. In the right foreground is the First Presbyterian Church.

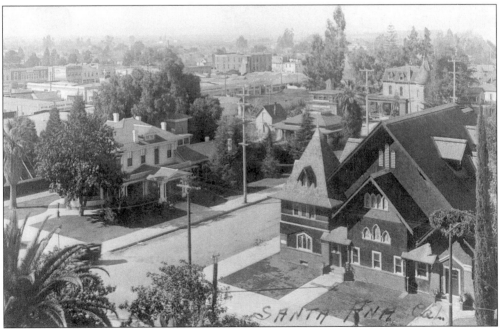

SOUTHWEST VIEW FROM COURTHOUSE. This interesting view is looking to the southwest from the courthouse. In the foreground (at right) is the First Christian Church at Sixth and Broadway, with the Smith Tuthill Mortuary (today's California Federal Savings) across the street. In the distance (at center) is the Hotel Richelieu at Fourth and Ross.

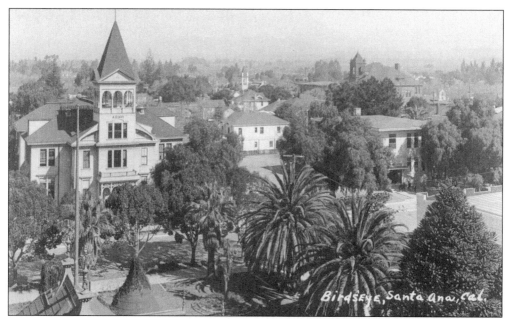

BIRDS-EYE VIEW. This interesting view looks to the north from the county courthouse. The county jail is in the immediate foreground. Across Church Street is the Central Grammar School, and to the right is Santa Ana's first school, called the Pioneer School. Beyond on Northeast is the old Santa Ana High School. This card is from about 1920.

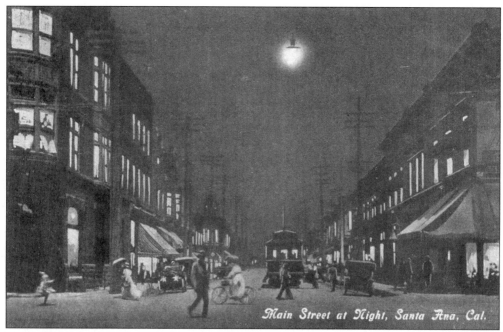

EARLY MAIN STREET AT NIGHT. Pictured above is an early 1920s nighttime view of Main Street looking to the north. Just a block away you can see a northbound Pacific Electric trolley bound for the PE Terminal at Lemon Street and Chapman Avenue.

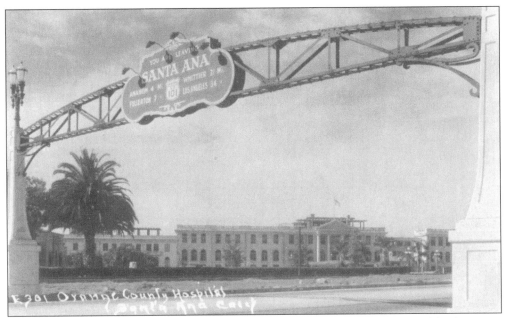

WELCOME TO SANTA ANA. This sign was located on Highway 101 at roughly the same location as where the Santa Ana Freeway today crosses Chapman Avenue. The scene dates back long before the construction of the freeway. The building in the distance is the Orange County Hospital, designed by Frederick Eley and built in 1914.

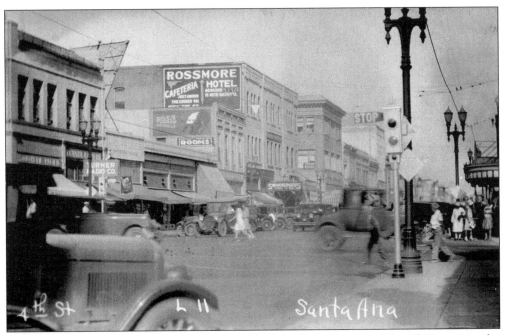

ROSSMORE CAFETERIA AND HOTEL. This wonderful photo featuring Fourth Street in the 1930s shows details of the period—stop lights, street lights, and electrical Red Car wires. This view is to the east from Broadway and shows the Rossmore Hotel at Fourth and Sycamore. Rankin's Department Store is just beyond that.

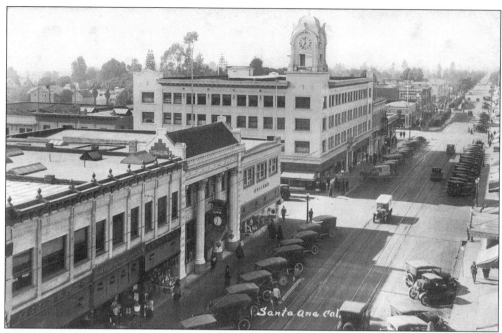

1920s Downtown. This view shows Fourth Street from Main, *c.* 1920. The Spurgeon Building and Clock Tower (built 1913) are at the center. The Neo-Classical-style Orange County Savings and Trust building (built 1911) is on the left foreground.

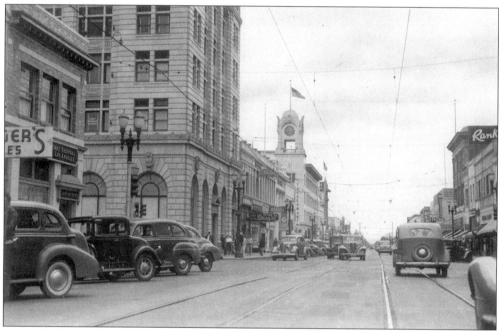

First National Bank Building. From this view (*c.* 1940s), you can see the ground floor of the newer First National Bank building on the left, the Spurgeon Building in the center, and Rankin's Department Store on the right. Notice the street rails and the electrical lines for the Pacific Red Car.

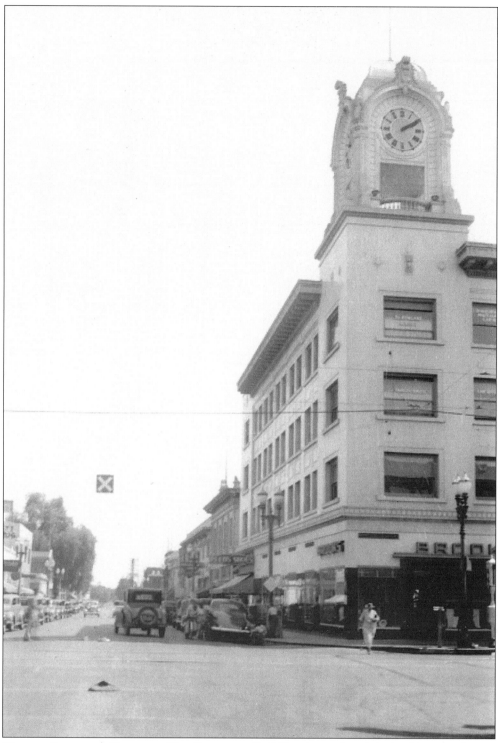

WILLIAM SPURGEON BUILDING. The Spurgeon Building is on the right looking south on Sycamore from Fourth Street.

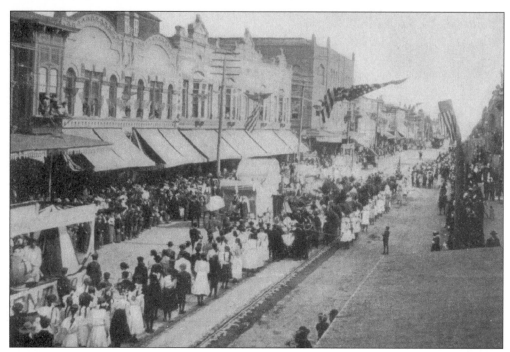

PARADE (1). This is a view of the middle of the 100 block of East Fourth Street, looking east. The date is 1905.

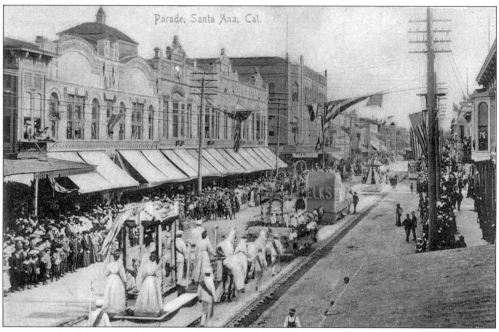

PARADE (2). This is another view of the 100 block of East Fourth Street. Note the horse-drawn floats, as well as the float celebrating the benevolent work of the local Elks Lodge.

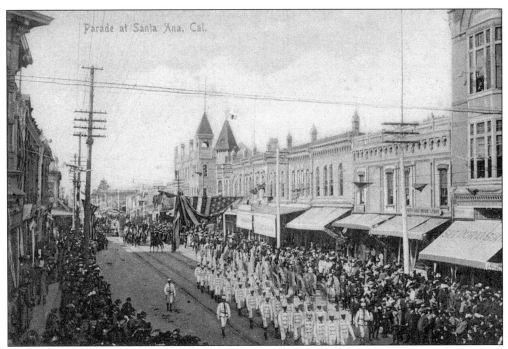

PARADE (3). Marchers are heading east in the 100 block of West Fourth Street. The tallest building on the right in the distance is the Rossmore Hotel at Fourth and Sycamore.

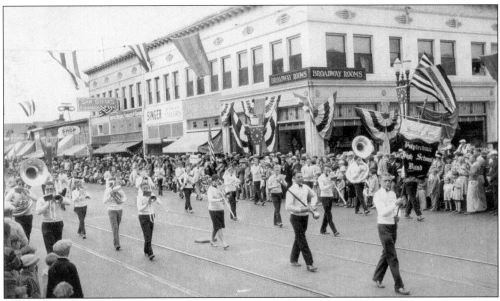

POLYTECHNIC MARCHING BAND. The Santa Ana Polytechnic High School band is pictured marching east on Fourth Street. The building in the background is actually composed of three separate buildings with a shared facade. Note the well-known "Sam Stein's, Of Course," stationery store, just left of center.

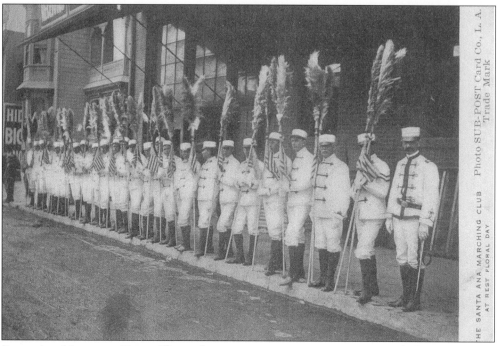

SANTA ANA MARCHING BAND. These dapper young gents are getting ready for the parade at something called the Rest Floral Day. We assume the date to be the early 1900s.

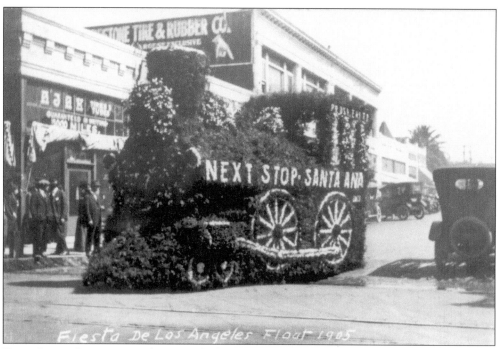

NEXT STOP—SANTA ANA. This parade float was destined for the Fiesta de Los Angeles Parade in 1905. The photo was taken on Fourth Street, east of French.

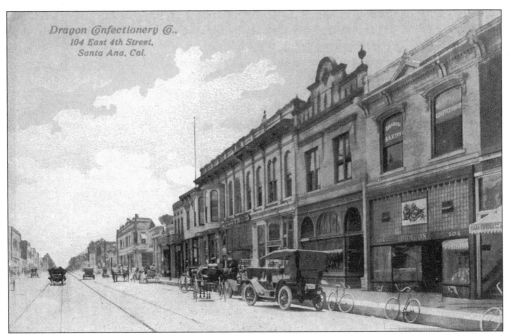

DRAGON CONFECTIONERY COMPANY. This excellent view of the south side of the 100 block of East Fourth Street shows Dragon Confectionery on the right, *c.* 1907. The Hervey-Finely Building is at the center in the distance (at Fourth and Bush).

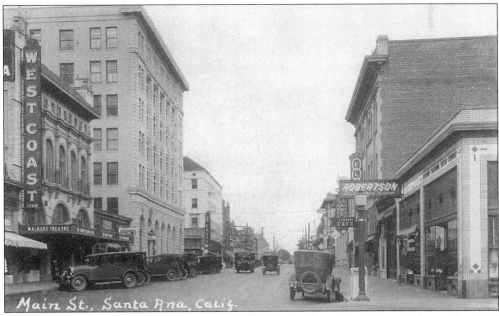

WEST COAST THEATRE. The West Coast Theatre stands to the left and faces the Odd Fellows Building on Main Street. In the left distance is the Otis Building (built 1926) at Fourth and Main, the traditional center of the business district.

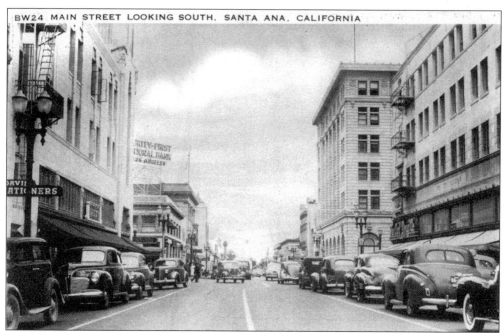

MAIN STREET LOOKING SOUTH (*c.* 1940). This view of the corner at Fourth Street shows (moving clockwise), the Montgomery Ward store, the Dibble Building (an early home of the J.S. Flour Company), and the Odd Fellows Hall on the left side. On the right side you see the six-story First National building and the Otis Building.

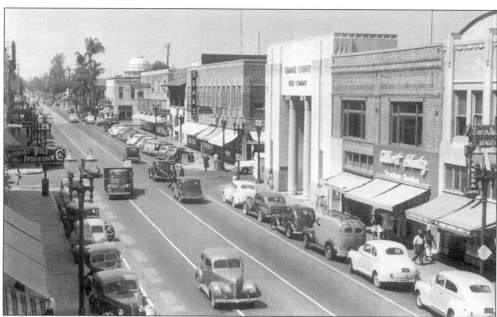

MAIN STREET (*c.* 1946). Orange County Title Insurance is the most prominent building in this view looking north up Main Street (likely photographed from the Otis Building at Fourth and Main). In the next block on the right one can see Sears, the Arcade Building, and Horton's Furniture Store. The domed building is the Congregational Church.

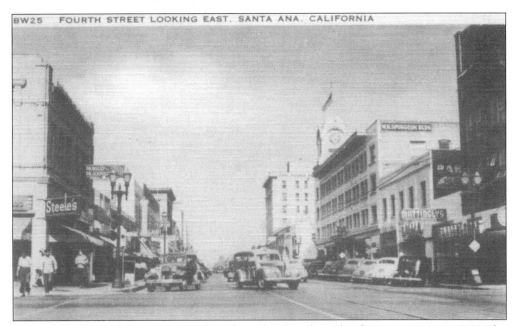

FOURTH STREET. A dominant and identifying landmark in the downtown since 1913, the William Spurgeon Building (in right center) in the distance at Fourth and Sycamore has played a significant role in the commerce of Santa Ana for nearly a century. This photo was taken at Broadway looking east, *c.* late 1940s.

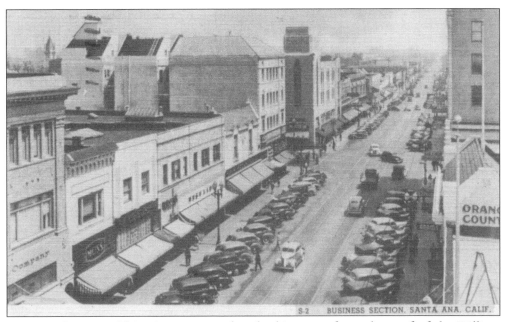

BUSINESS DISTRICT. This picture was taken looking east from the roof of the William Spurgeon Building at 206 West Fourth Street. You can see the Orange County Savings and Trust sign on the far right. The cars place the date *c.* 1940—and then, as now, street parking was at a premium. Note the charming awnings that provided shade for pedestrians and reduced glare in store windows.

35

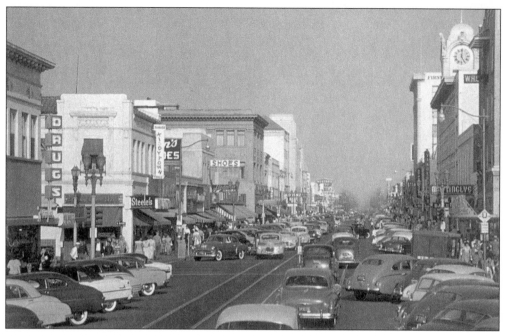

FOURTH STREET. This is a view of Fourth Street looking east from Broadway, *c.* 1957.

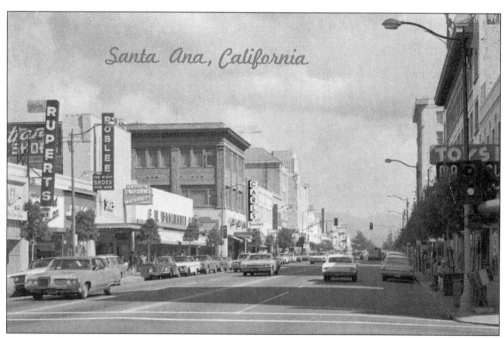

FOURTH STREET. Ten years later, this is a similar view of Fourth Street from the photo above, again looking east from Broadway, but *c.* 1966. You can clearly see the F.W. Woolworth Building on the left, just before the three-story Rankin Building.

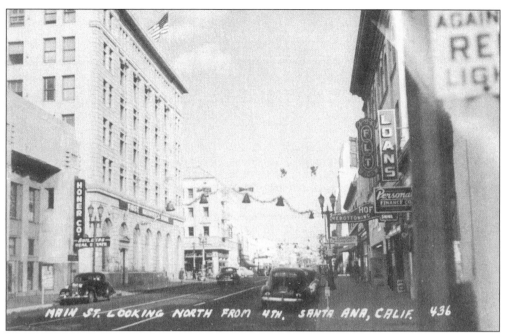

MAIN STREET (WINTER). This is a nice Christmas time view of the downtown area. This time, you're looking north up Main Street from about Third Street, *c*. 1950.

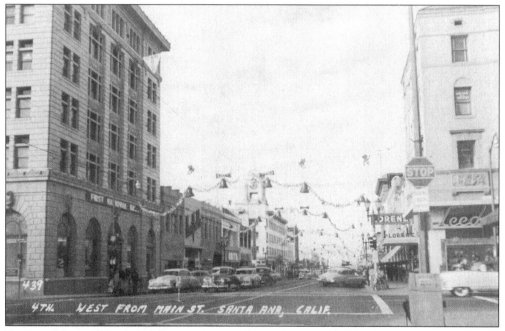

FOURTH STREET (WINTER). This is a view of Fourth Street from Main, *c*. 1950. Note the Christmas bell decorations hanging across the street. The building on the left is the First National Bank. The one on the right (with Leeds on the ground floor) is the Otis Building.

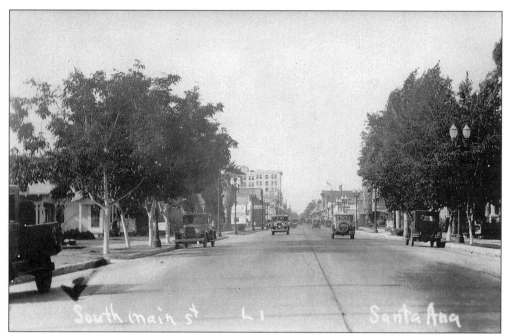

SOUTH MAIN STREET. This 1920s view is of Main Street looking north from Chestnut Avenue. Note the downtown area in the center, with the six-story First National Bank building rising high above the other buildings.

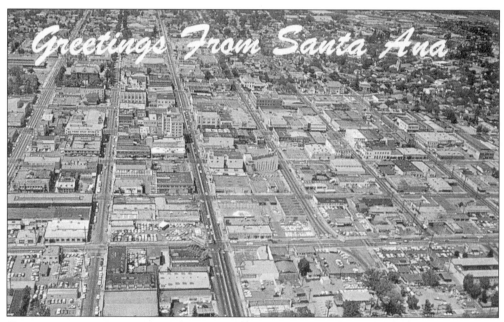

GREETINGS FROM SANTA ANA. This view photographed by George Watson dates from about 1958 and shows the central part of the city. In the center of the photo you see the Fourth Street shopping district, which included Montgomery Ward, Kress, and J.C. Penney's stores in the 100 block of East Fourth Street. Also illustrated is the concentration of automotive related uses along First Street at the edge of downtown.

BROADWAY. This is a view of North Broadway, looking northward from about Twentieth Street, *c.* 1957.

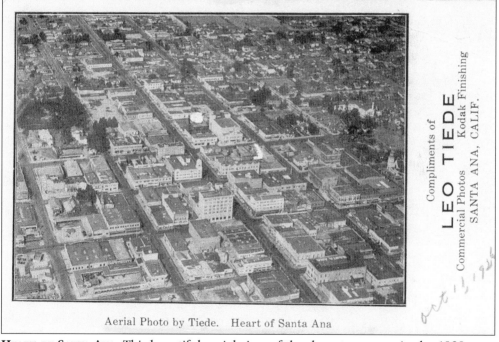

Aerial Photo by Tiede. Heart of Santa Ana

HEART OF SANTA ANA. This beautiful aerial view of the downtown area in the 1920s was photographed by Leo Tiede, a noted local photographer. The Spurgeon Building, with its signature clock tower, and the Rossmore Hotel appear in the center of the photograph. To the right is the county courthouse.

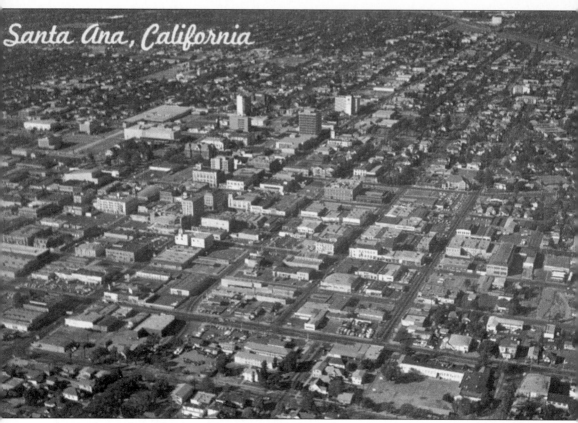

Santa Ana, California

AERIAL SANTA ANA. This is a downtown view from the mid-1960s looking north. One can see three "downtowns" now developing: the original Fourth Street core business district, the Civic Center to the center left, and the Main Street Financial District marked by three high-rise towers including the 1965 Security Pacific Tower at 888 Main Street. In the lower right hand corner is Roosevelt Elementary School (412 East First Street), built in 1924.

Three
CIVIL, COMMERCIAL, AND LANDMARK BUILDINGS

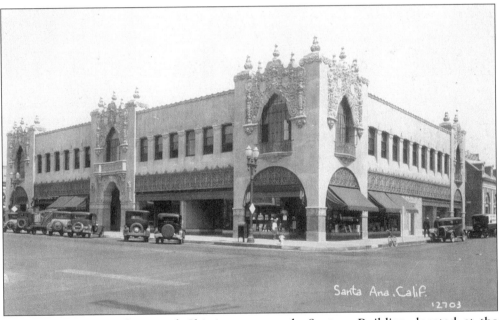

Santa Ana, Calif.

12703

SANTORA BUILDING. The grand Chirriguresque-style Santora Building, located at the corner of Broadway and Second Streets, was built in 1926 by the Santora Land Company and represented the pinnacle of luxury in an office building. A spacious two-story lobby on the second floor led to offices with large windows facing both to the exterior and the lobby. The building was restored to its original beauty in the 1980s. The Santora is now one of the main buildings for the Artists Village project, which has taken root in that part of downtown. To the far right in the picture you see the Southern Counties Gas Company building, which still stands.

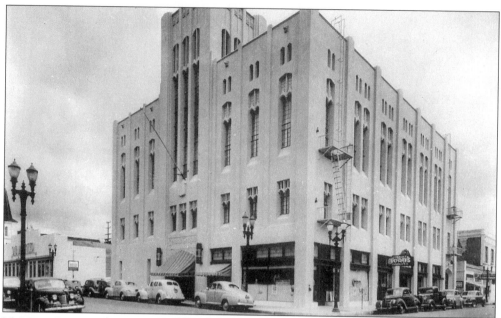

MASONIC LODGE. This was the fifth Masonic Temple building for Santa Ana Lodge No. 241 F.&A.M. It was dedicated in 1931 and cost $300,000 to build. It closed in 1984 due to seismic concerns, and the lodge combined with one in Tustin. Recently a new owner has lovingly restored the beautiful building for use as cultural arts and event center.

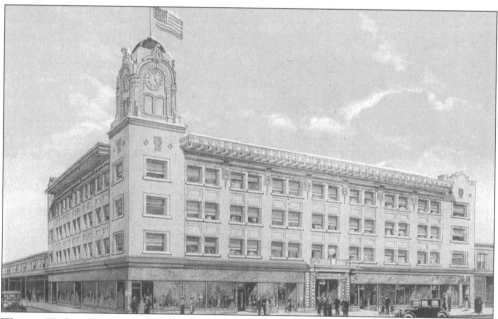

WILLIAM H. SPURGEON BUILDING. This building is located on the southwest corner of Fourth and Sycamore and was built in 1913. There were two preceding Spurgeon Buildings at the same site. The clock tower had fallen into disrepair over the years and had stopped working. In 1996, local residents and businesses, with the help of civic groups and clock collectors, raised private funds to repair and restore the clock to its former glory.

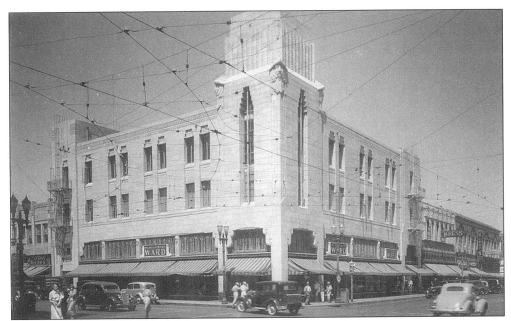

MONTGOMERY WARD. This Montgomery Ward Store building was located on the northeast corner of Fourth and Main Streets for many years, and was vacated when Ward relocated to Honer Plaza in 1960. This spectacular building of sandstone was torn down in 1975. Note the electric lines for the Electric Railway system.

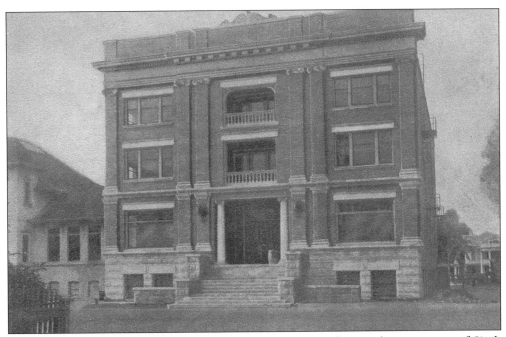

SANTA ANA ELKS LODGE The Elks building was located at the southwest corner of Sixth and Sycamore, next to the Carnegie Library building. The building in the background to the right is the Smith-Tuthill Mortuary located at Sixth and Broadway.

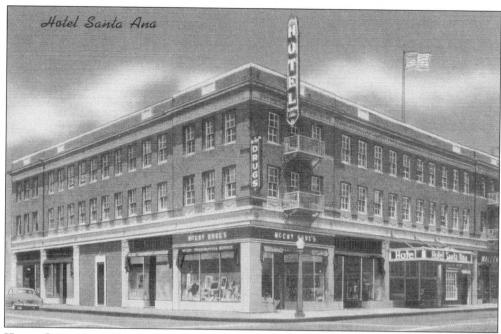

HOTEL SANTA ANA. This was a comfortable hotel for those doing business in the city or just visiting. Built in 1922, it was situated at the corner of Main and Sixth Streets. The corner store of the building was McCoy's Drug Store. The aging building was eventually demolished in the mid-1980s for use as a parking lot for the First Presbyterian Church.

AMERICAN LEGION HALL. The Legion Hall is located at 313 N. Birch Street. The interior was destroyed by fire on Christmas Day in 1982. It was restored for office use in 1993–94.

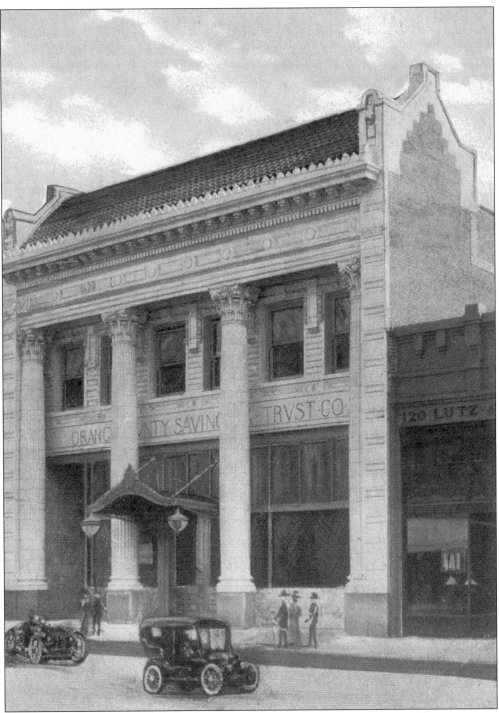

ORANGE COUNTY SAVINGS AND TRUST CO. This landmark building, with its imposing two-story columns, was located in the 100 block of West Fourth Street, *c.* 1910. Like other financial institutions of the day, it was designed to engender feelings of dignity, safety, respect, and confidence that "your money is safe with us."

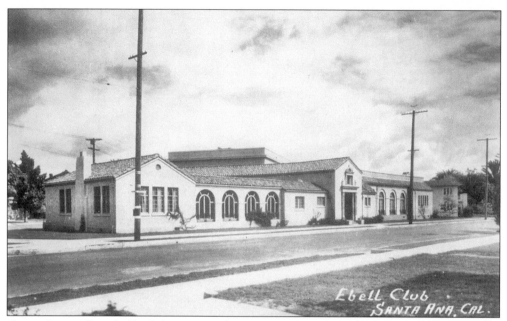

EBELL CLUB. The Ebell Club House, 625 N. French Street, is the home of the Ebell Society of the Santa Ana Valley—a women's organization that enriches the social lives of its members and helps the community through its philanthropic work. The Ebell Society of Santa Ana Valley was founded in the 1890s. The building was built in 1923 and designed by Frederick Eley.

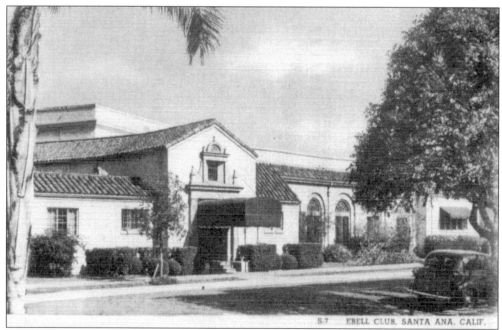

EBELL CLUB. This is a close-up of the west elevation of the Ebell Club House. The club house is also rented to outside organizations for meetings, shows, and other events.

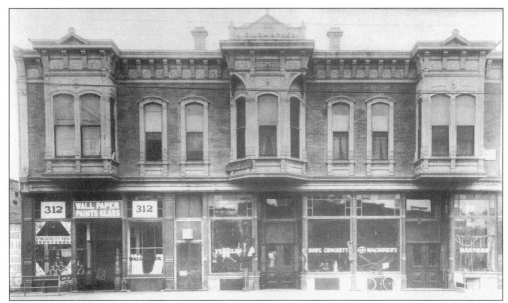

GILDMACHER BUILDING (1887). This building at 312–314–316 W. Fourth Street was built by A.F. Gildmacher, a key downtown merchant in the 1880s who extended credit to farmers in the Santa Ana Valley. The building's facade was radically changed following the 1933 earthquake. The upper floor interior was restored in the 1980s and retains the characteristics of a Victorian commercial building.

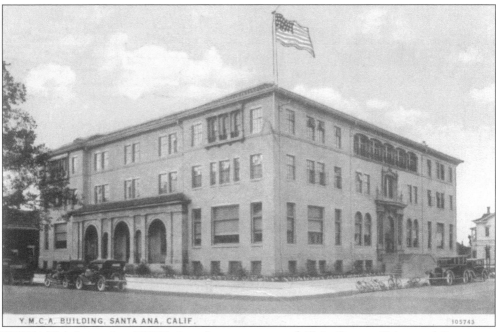

Y.M.C.A. BUILDING, SANTA ANA, CALIF.

YMCA. The Santa Ana YMCA (northwest corner of Civic Center Drive and Sycamore Street) was built in 1923–24 for approximately $234,000. It was designed by Frederick Eley. Toastmasters International was founded in the basement of this building by Ralph Smedley. Toastmasters began in 1924 as a self-improvement club for YMCA members.

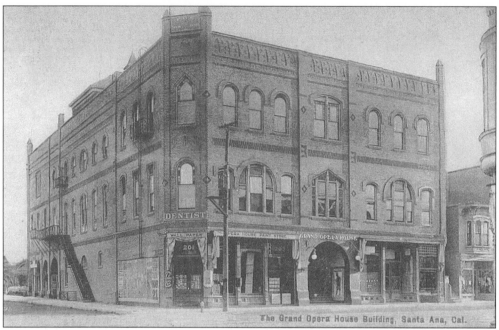

THE GRAND OPERA HOUSE. The opera house was built at the northeast corner of Fourth and Bush Streets in 1890 by C.E. French. Madame Modjeska performed here in the early days. This building was demolished and later became the site of the W.T. Grant department store. It too was torn down as part of the 1986 Fiesta Market Place redevelopment project.

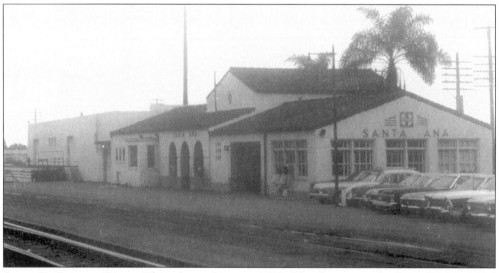

SANTA FE RAILWAY DEPOT. This photo dates to 1973. The depot was built in 1938 at 1034 E. Fourth Street and was closed in 1985. Following a fire, the depot was torn down in the late 1980s. Santa Fe was the second railway to reach Santa Ana (1887). The Southern Pacific railway had arrived in 1877.

SANTA ANA COMMUNITY HOSPITAL. Located at 600 East Washington Avenue, it became Santa Ana-Tustin Community Hospital and relocated to a new facility at 1001 North Tustin Avenue—now known as Western Medical Center. The original building continues as a convalescent care center.

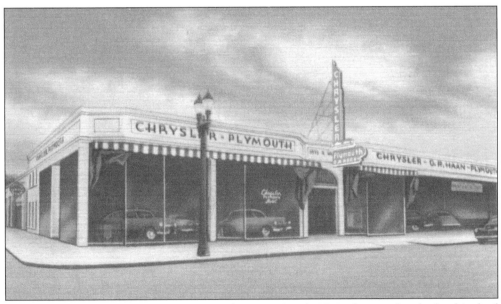

O.R. HAAN CHRYSLER-PLYMOUTH. Located at 505 South Main Street, the dealership had been in Santa Ana for over 40 years. The postcard claimed "the most modern and best equipped shop in Orange County." The building is now used as a furniture store.

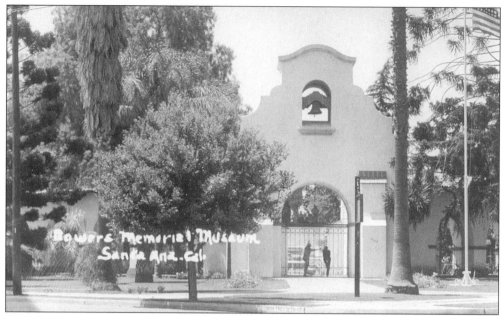

BOWERS MEMORIAL MUSEUM. Ada and Charles Bowers willed their homestead for the creation of a museum to celebrate Orange County history. A new two-story Spanish Colonial Revival-style museum was built, opening in 1936. In the late 1980s, the museum closed for a major expansion and remodeling; it reopened in 1992 and was renamed the Bowers Museum of Cultural Art to include the culture and art of Pacific Rim countries.

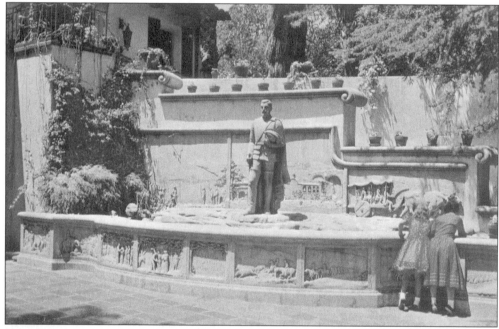

MRS. CHARLES M. BOWERS MEMORIAL FOUNTAIN. A statue of Juan Rodriquez Cabrillo, an early California explorer, graces this fountain in the patio of the Bowers Museum. Behind and in front of the statue are bas-reliefs depicting scenes of early California.

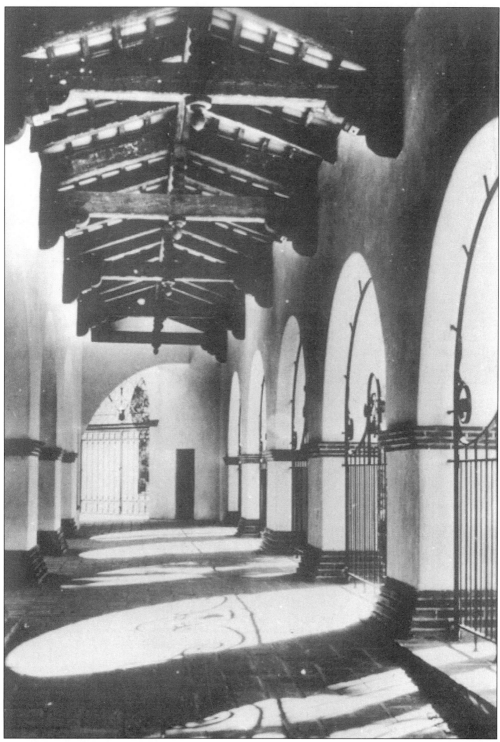

Mission Architecture. This view of the east corridor of the Bowers Museum shows the museum's California Mission architectural heritage.

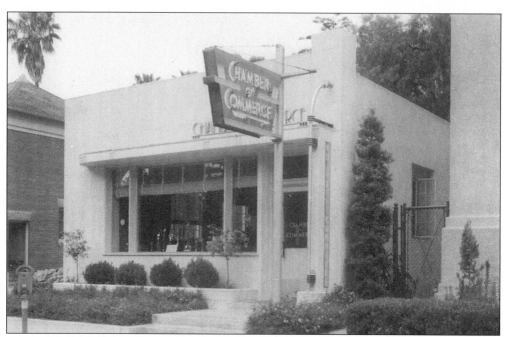

SANTA ANA CHAMBER OF COMMERCE. Begun in 1888, the Chamber has played a major role in the growth of Santa Ana. This building was one of their offices during the years and is located on the 200 block of West Eighth Street. Today, it is used by the community organization, Taller San Jose.

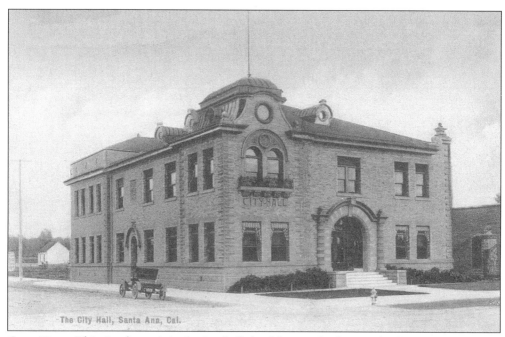

CITY HALL. This is the original city hall building, which was built in 1903 at the southeast corner of Third and Main Streets. It was damaged in the 1933 Long Beach Earthquake and was soon demolished and replaced with the building on the next page.

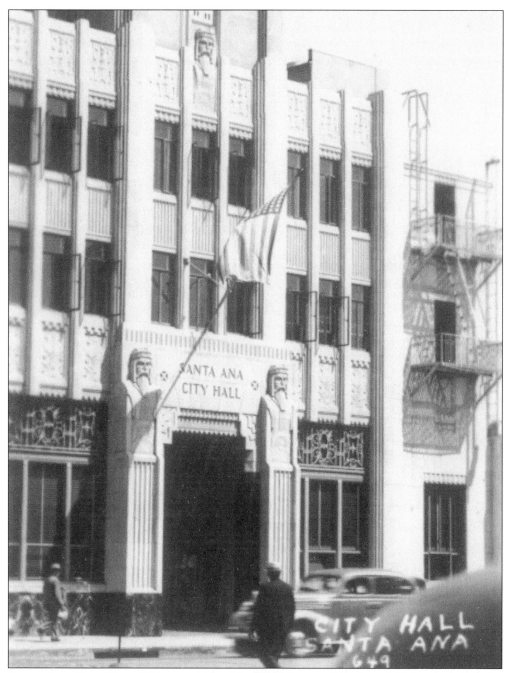

SANTA ANA CITY HALL. This proud-looking building at Third and Main replaced the previous city hall in late 1935—after it had been rendered unsafe in the 6.3 earthquake of 1933. The structure was designed by Austin and Wildman and built by the Allison Honer Company. The building was a WPA project, with the city receiving $30,000 in federal grants to supplement the $85,000 paid by the city. This building was vacated in 1974, when the new city hall at Civic Center was opened. It was restored in the 1980s and is now used for commercial offices.

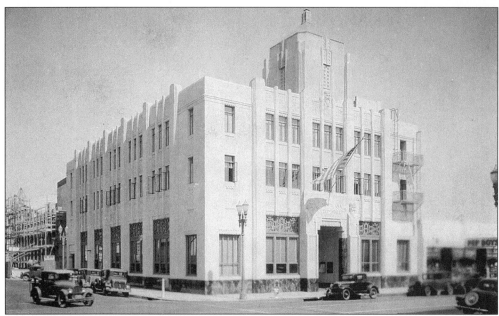

OLD CITY HALL. Distinctive Assyrian warriors guard the entrance of this older city hall building. The Moderne-style architecture and prominent tower on this symbol of municipal government conveyed an impression of strength and stability in the period of great economic instability during the 1930s.

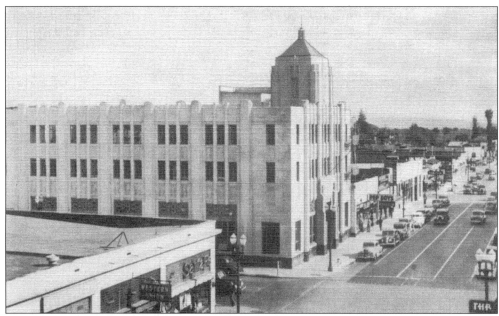

OLD CITY HALL. The Western Union office in the lower left center of the image indicates that this view of city hall probably was taken in the late 1930s from atop the First National Bank building at Fourth and Main.

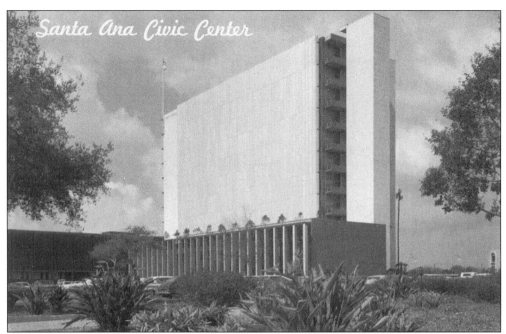

ORANGE COUNTY COURTHOUSE. Built in 1966 and located on 700 Civic Center Drive, the courthouse was one of the key buildings when the Civic Center complex was created in the center of downtown Santa Ana. The structure was designed by Richard Neutra.

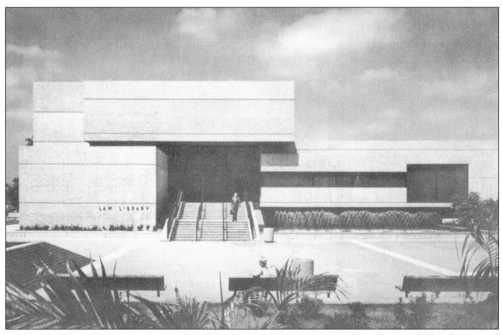

ORANGE COUNTY LAW LIBRARY. This building (built 1973), with its beautifully clean and sharp design, is located within the Civic Center complex. The law library was designed by Santa Ana architect Ralph Allen, who has also designed a number of Santa Ana school projects, including Century High School and several elementary schools.

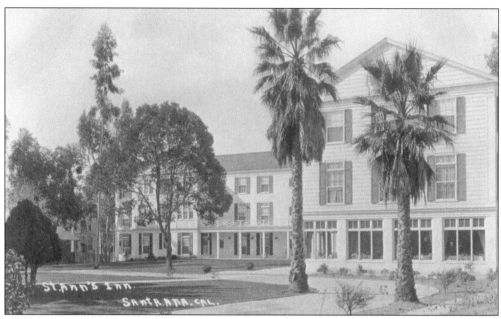

St. Ann's Inn. It was prophetic that this first-class hotel, built in the Colonial-Revival style on the northwest corner of Broadway and Sixth, opened on Valentine's Day 1921, because it became dear to the hearts and memories of Santa Ana residents until it was demolished in the 1970s to make way for the present County of Orange office buildings.

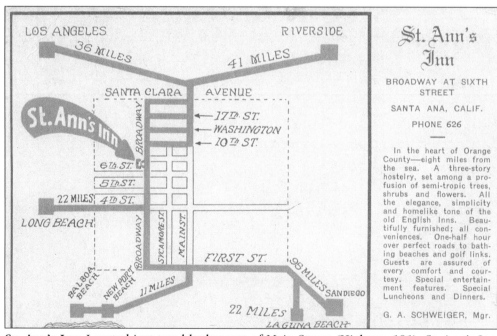

St. Ann's Inn. Located just two blocks west of Main Street (Highway 101), St. Ann's Inn was a world apart, a haven for honeymooners recently married at the County Courthouse and for other visitors who sought gracious accommodations. Note the three-digit phone number and the close proximity to "bathing beaches and golf links." Hmm

56

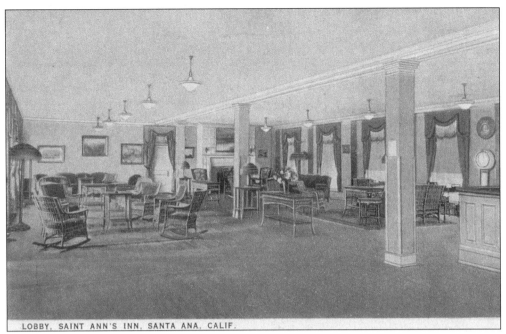

LOBBY, SAINT ANN'S INN, SANTA ANA, CALIF.

LOBBY, ST. ANN'S INN. Spacious and gracious, this served as the social center for guests, who enjoyed the inn's communal gathering place throughout the day and before meals, to relax in comfortable rocking chairs and visit with one another.

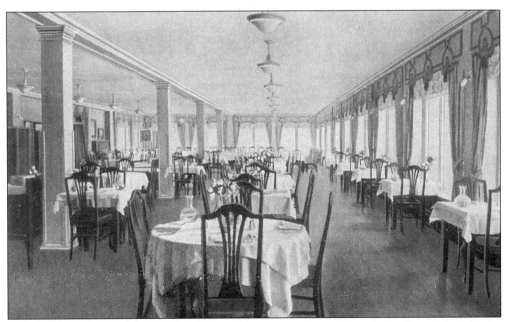

DINING ROOM, ST. ANN'S INN. Pristine starched white linen tablecloths and napkins, sparkling crystal, and shining silverware set the tone for fine dining at this establishment in an era when everyone "dressed" for meals, which were social occasions that required one's best manners.

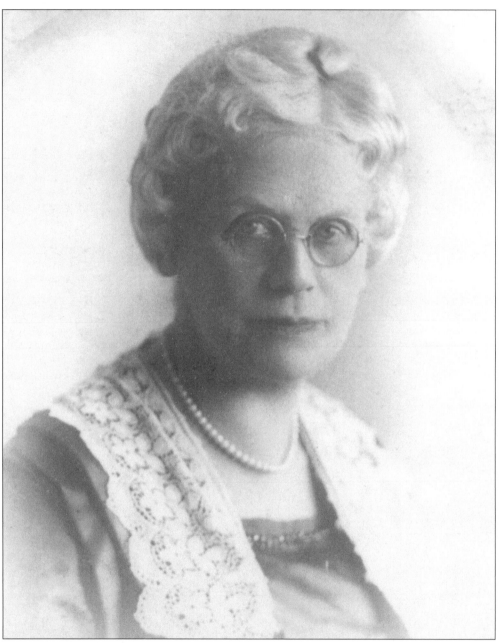

DR. WILLELLA HOWE-WAFFLE. At the turn of the century, Dr. Waffle was one of the leading physicians in Santa Ana and was the first female doctor in the Santa Ana Valley. She spent 44 years of amazing service to her community, having bore hundreds of babies and helped thousands more. During those days, a doctor might have to break their own road through cactus and mustard plants to get to a patient's house, and Dr. Willella, as she was known to patients, did so often. In the early days, she fought to gain the respect of her community, but the ones who fought her the most ended up good friends. Dr. Willella died at age 70 in November of 1924 while at the bedside of a patient at the Santa Ana Hospital. She left a legacy among those she helped and those who still honor her.

Dr. Willella Howe-Waffle House and Medical Museum. Built in 1887–1889, the Queen Anne Victorian-style house features two stories and twelve rooms. It cost $8,000 to build, a grand sum for the time. In 1974, the Santa Ana Historical Preservation Society was organized by Adeline Walker to save the house from demolition due to a street-widening project. The house was moved to the corner of Civic Center and Sycamore and was beautifully restored by scores of volunteers and donations by residents, businesses, and the city government. Today the house is open to all as the house museum of the society.

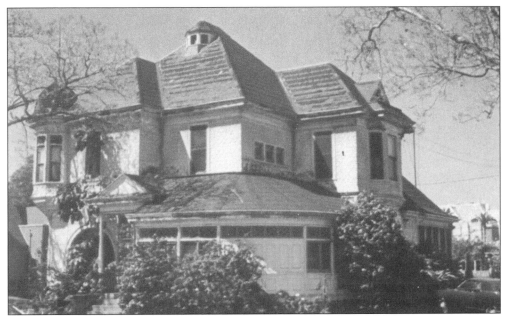

Pre-Restored Howe-Waffle House. This picture shows the condition of the Howe-Waffle House before it was moved from Bush Street and restored. After Dr. Willella's death, the house would see several owners and eventually fall into severe disrepair.

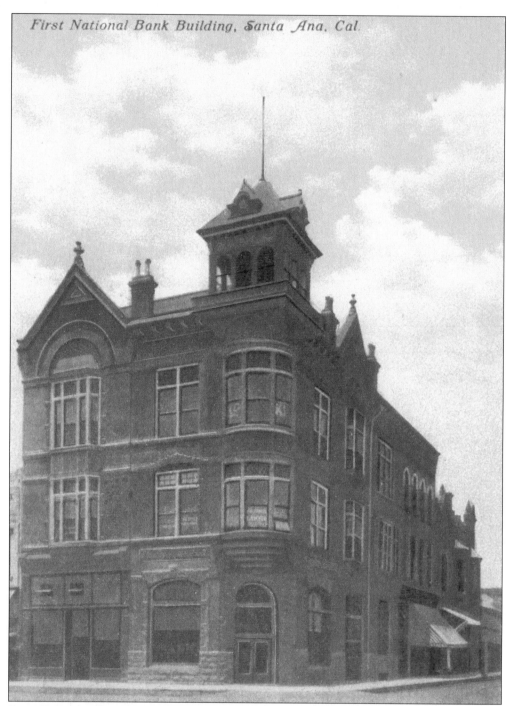

First National Bank Building, Santa Ana, Cal.

FIRST NATIONAL BANK BUILDING. The prominent building stood on the northwest corner of Fourth and Main Streets. For many years it was the tallest building in Santa Ana. The building dates back to about 1889, soon after the Santa Fe Railroad arrived and helped to create a boom period of growth. The bank moved out and to new headquarters across the street in 1923. The building became the Otis Building in 1926 after an extensive remodel.

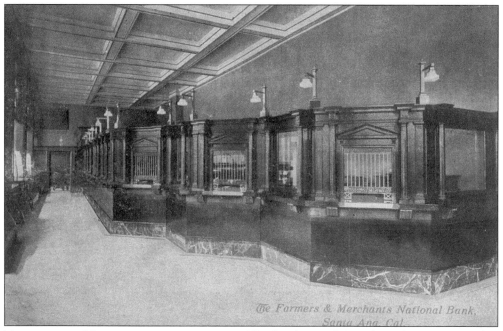

FARMERS AND MERCHANTS NATIONAL BANK. The bank was located in the Hervey-Finley Bank at Fourth and Bush Streets.

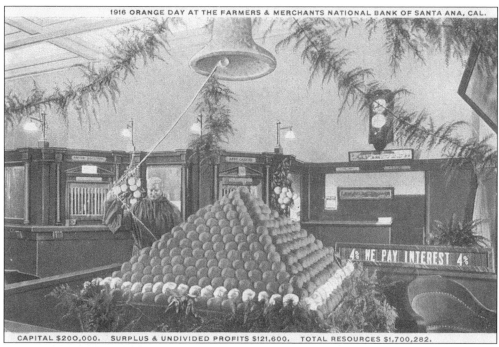

ORANGE DAY (1916). This is a very interesting promotional celebration by Farmers and Merchants National Bank. The back of the card noted that Orange County crop values in 1915 included: sugar beets—$6,750,000; oranges—$4,150,000; beans—$2,100,000; and walnuts—$1,600,000.

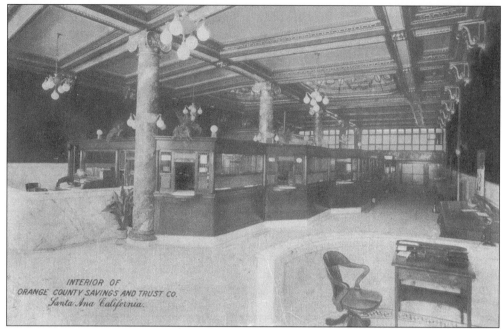

ORANGE COUNTY SAVINGS (1911). This is a view of the interior of the Orange County Savings and Trust at 116 West Fourth Street. O.C. Savings was incorporated in 1889. In 1912, they had capital and reserves of $318,875. You could rent a safe deposit box for $1.50 per year. W.A. Zimmerman was president, and C.E. French was vice president.

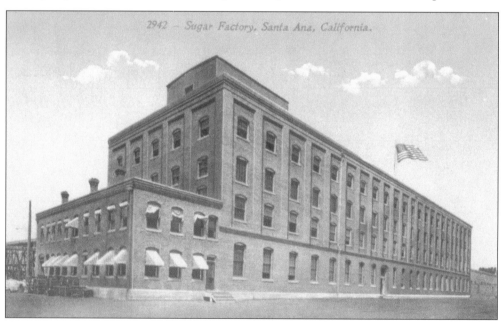

SOUTHERN CALIFORNIA SUGAR COMPANY (c. 1915). This building was located on South Main Street, south of Warner (then called Delhi). Some of this structure is still intact and being used for commercial purposes. At one time, there were five large sugar-making plants in Orange County, representing nearly 20 percent of the nation's entire output.

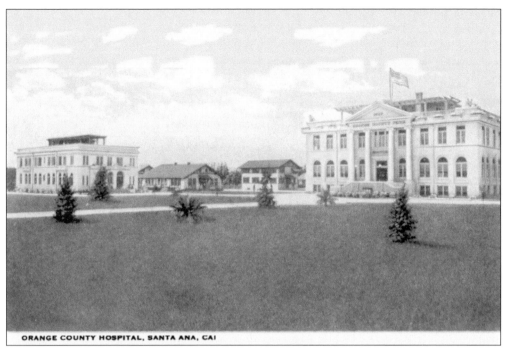

ORANGE COUNTY HOSPITAL, SANTA ANA, CAI

ORANGE COUNTY HOSPITAL. This hospital was built by contractor Chris McNeill in 1914, and was designed by Frederick Eley. At one time the hospital was referred to as the Orange County Poor Farm. This building today remains as part of the UCI Medical Center.

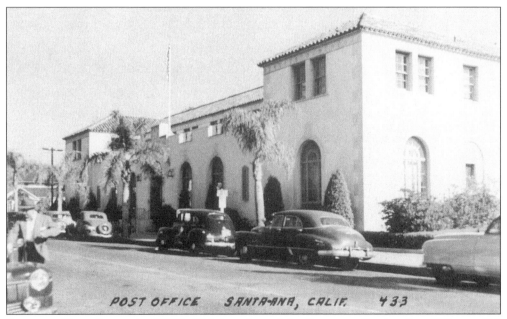

POST OFFICE SANTA-ANA, CALIF. 433

SPURGEON POST OFFICE (c. 1950). This is a view of the Spurgeon Station Post Office at 615 North Bush Street. It was built in the 1930s and continues to serve its postal customers well.

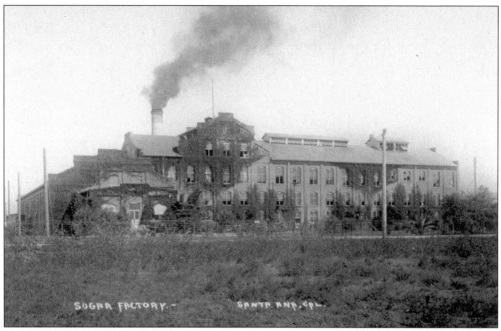

HOLLY SUGAR FACTORY. Located on East Dyer Road, the Holly Sugar Factory (built *c*. 1912) was torn down in 1983, following a battle to save it launched by Heritage Orange County. It was replaced with the 1985 development of the Birtcher Orange County Tech Center.

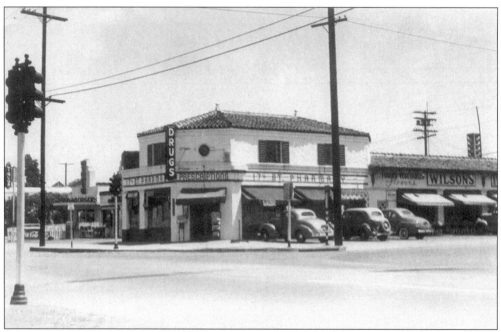

SEVENTEENTH STREET PHARMACY (*c*. **1948**). This drug store was located at the corner of Main and Seventeenth Streets. Note the direct parking of cars on Seventeenth Street. Wilson's Seventeenth Street Market is next door.

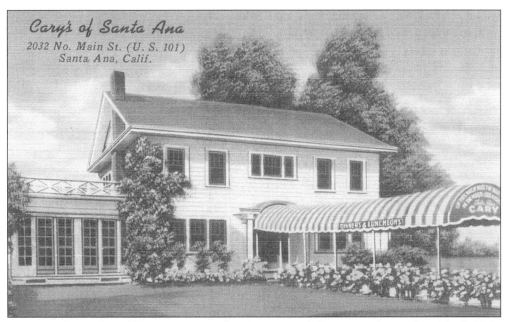

CARY'S OF SANTA ANA. Cary's was a popular restaurant and rest stop located on North Main Street. Owned by Clint and Edna Cary, the restaurant was well known for their steaks and seafood. Main Street was part of the Highway 101 road system, which was a major path for those traveling from Los Angeles to San Diego (prior to our local freeway system).

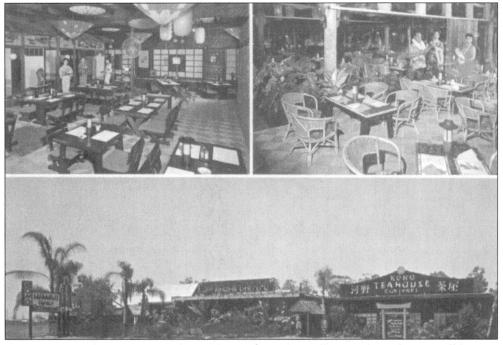

KONO HAWAII. This restaurant, located at 226 South Harbor Boulevard, was well known for its entertainment (Don Ho performed there) and indoor streams populated by Koi fish. The Diocese of Orange plans to construct a new church at this site.

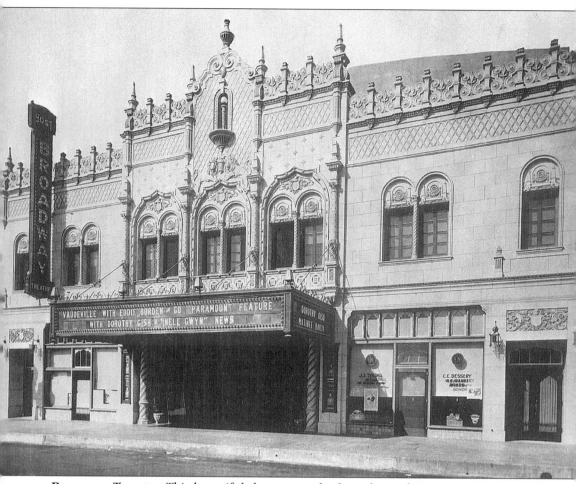

BROADWAY THEATRE. This beautiful theatre was built in the mid-1920s and designed in the same Moorish-Revival style as the Knights of Phythias Hall next door. The structure was severely damaged from a fire in the 1950s and was rebuilt in a modern style. The building was eventually torn down. When this photo was taken, Vaudeville with Eddie Borden was being featured.

Four

LIBRARIES, CHURCHES, AND SCHOOLS

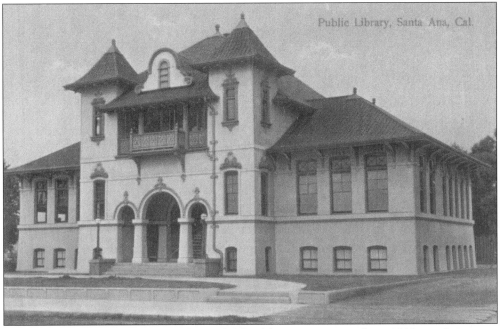

CARNEGIE PUBLIC LIBRARY. This beautiful building was opened in 1903 on Sycamore Street just south of the county courthouse. A generous grant of $15,000 from the Carnegie Foundation, and the donation of the land from William Spurgeon, brought what was a hodgepodge of five city library collections to one central location. The building was designed in the Mission/Spanish Colonial Revival style by architects Blither, Dennis, and Farwell, and was built by J.W. Blee and Chris McNeil. Jeanette McFadden, the daughter of a prominent pioneer family, was appointed head librarian in 1901. When the library first opened, only the main floor was occupied. By 1910, the library was becoming crowded due to its popularity and amount of books. (A condition of the Carnegie Grant was that there be regular city funding for books.) This building was demolished soon after the new library building was opened in 1960.

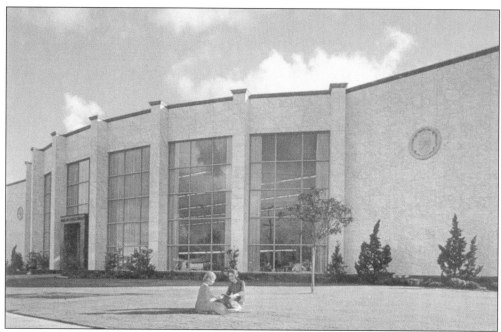

SANTA ANA PUBLIC LIBRARY. The current Santa Ana Public Library main building was dedicated in May 1960, and is located at Civic Center Drive and Ross Street. The cost of the 40,000-square-foot building was $805,000. The old Carnegie Library building was demolished after this new, modern library opened.

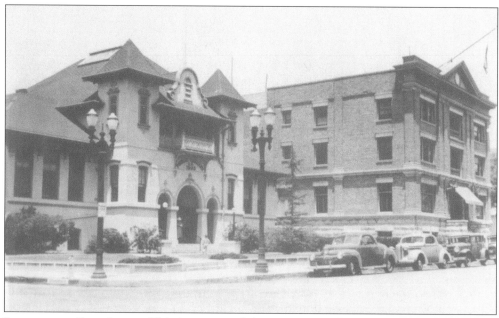

LIBRARY AND ELKS LODGE. This is a view of the Carnegie Library building and the Elks Lodge (BPOE #794) on Sycamore, between Fifth and Sixth Streets, in the 1930s.

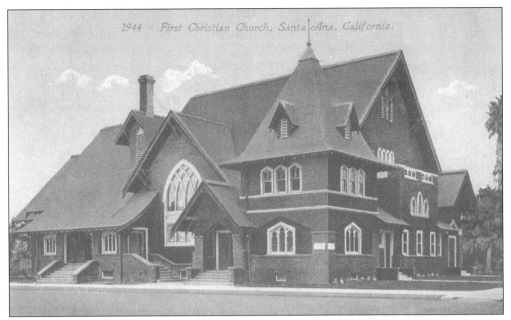

FIRST CHRISTIAN CHURCH. The church was located at the northeast corner of Sixth (today, Santa Ana Boulevard) and Broadway. The building (the congregation's second) was built in 1910. The church was torn down a number of years ago, and today this is the location of the County Hall of Administration.

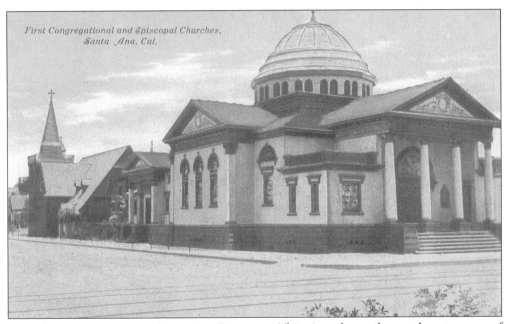

FIRST CONGREGATIONAL AND EPISCOPAL CHURCHES. This view shows the southeast corner of Seventh and Bush Streets. In the foreground is the First Congregational Church; beyond that is the Episcopal Church of the Messiah, which remains today. The latter was built in 1889, and designed by Ernest Coxhead, a prominent late-19th-century California architect.

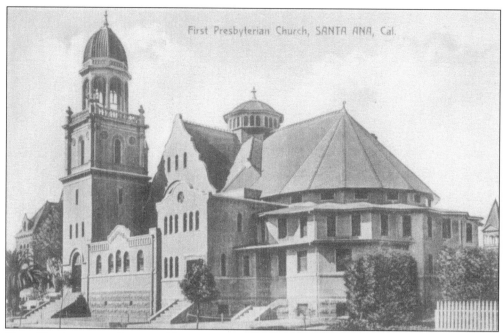

FIRST PRESBYTERIAN CHURCH. This view of First Presbyterian is looking in the northwest direction from Sixth Street (today, Santa Ana Boulevard), near Main. In the background and to the right, you can see a small part of the Central Grammar School. To the left is the county courthouse.

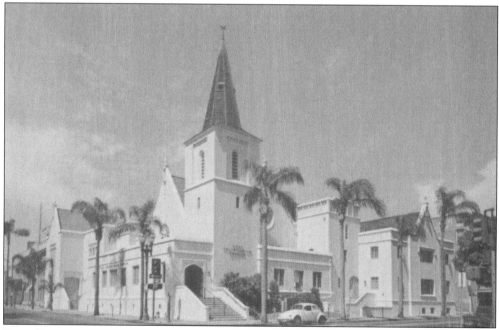

FIRST PRESBYTERIAN CHURCH, TODAY. This is how the church looks today. The photo appears to have been taken about 1970.

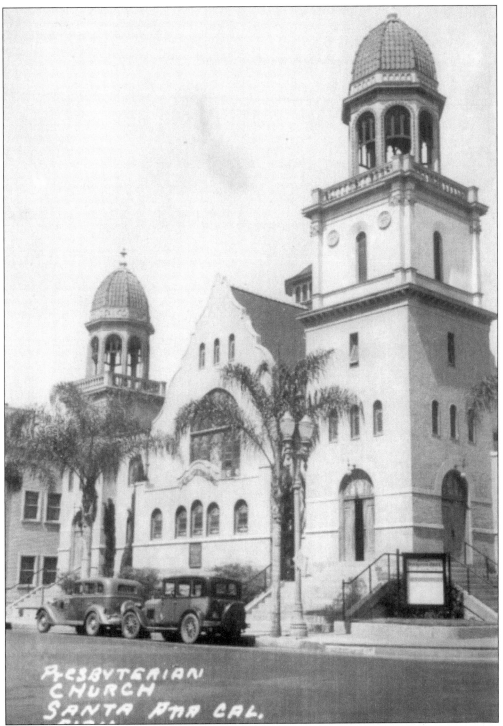

FIRST PRESBYTERIAN CHURCH, ANOTHER VIEW. This view of the church is looking northeast from the corner of Sycamore and Sixth. The photo is *c.* 1930, before the 1933 earthquake damaged parts of the building.

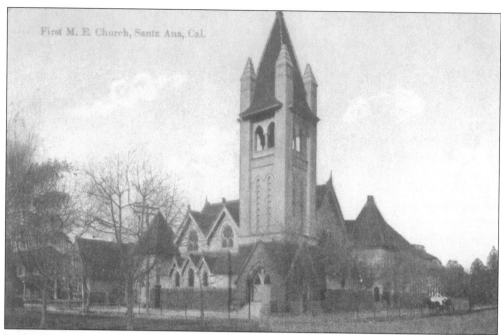

FIRST METHODIST EPISCOPAL CHURCH. This beautiful church was built in 1900 at the corner of Sixth and Spurgeon. The steeple never had a bell installed in it. The tower was removed following the earthquake in 1933. The main structure was razed in 1965 for the present church construction.

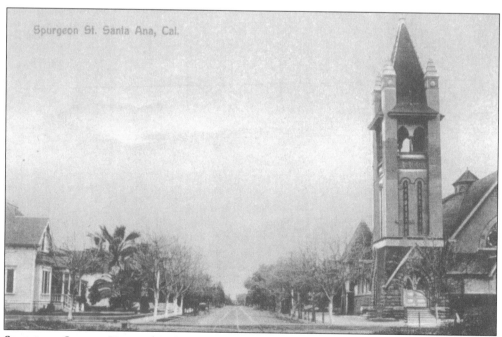

SPURGEON STREET. Pictured is Spurgeon Street looking north at Sixth Street. The First Methodist Church is on the right. Note the location of the houses on the left. Today, that is the site of the parking lot for the Spurgeon Station Post Office.

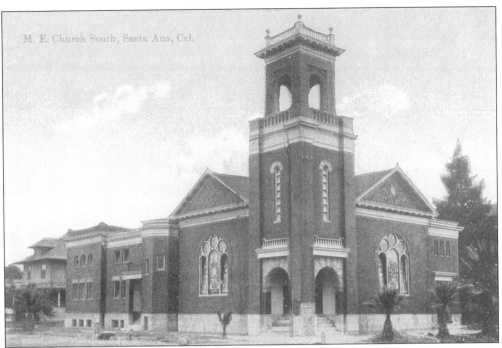

SPURGEON MEMORIAL METHODIST. This church was built in 1906 and located at the corner of Broadway and Church (Eighth Street). To members of this church belong the honor of establishing the first church in Santa Ana (1870).

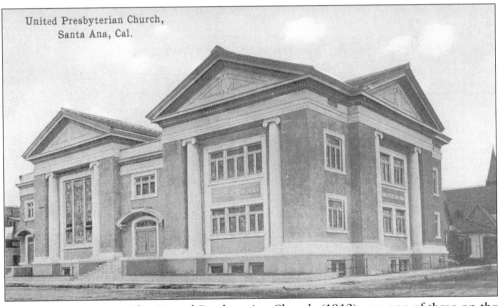

UNITED PRESBYTERIAN. The United Presbyterian Church (1912) was one of three on the block bounded by Sixth, Seventh, Main, and Bush Streets. The building remains standing at the northwest corner of Santa Ana Boulevard and Bush Streets. The church was renamed Trinity Presbyterian and relocated to Seventeenth and Prospect in the area known as North Tustin.

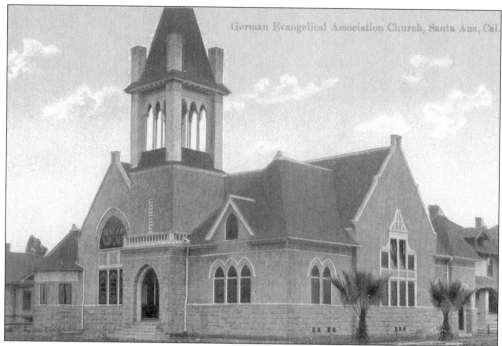

GERMAN EVANGELICAL ASSOCIATION CHURCH. This church was one of about 32 different churches in 1921 representing a wide variety of faiths. The card dates to about 1920.

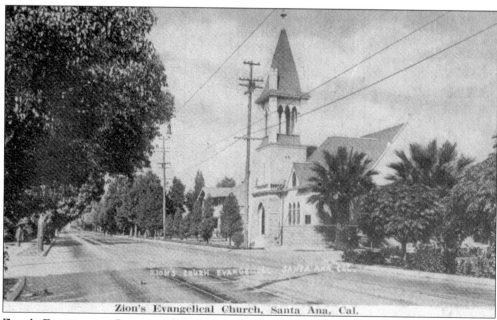

ZION'S EVANGELICAL CHURCH. The church was located on the outskirts of the downtown area. Also, notice the rail tracks in the street. This card dates to about 1905.

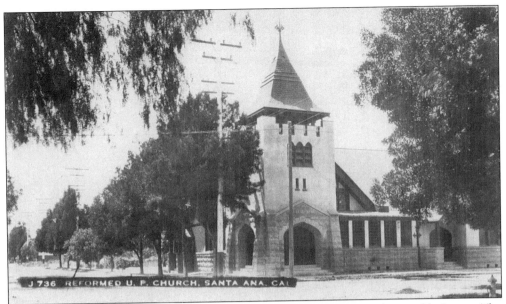

REFORMED UNITED PRESBYTERIAN CHURCH. This church was located on Fifth Street. The card dates to about 1905.

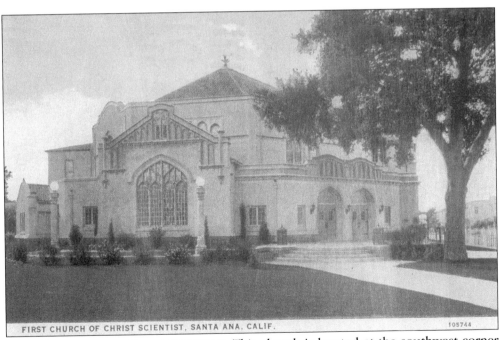

FIRST CHURCH OF THE CHRIST SCIENTIST. This church is located at the southwest corner of Tenth and Main Streets. The building is now used as a performance hall for the Orange County High School of the Arts.

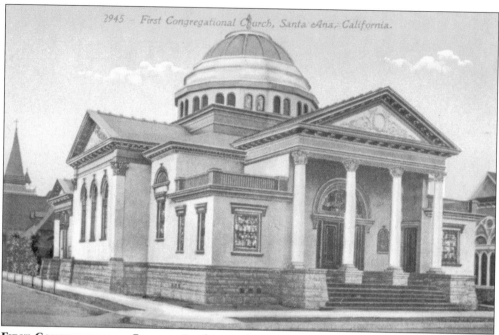

2945 First Congregational Church, Santa Ana, California.

FIRST CONGREGATIONAL CHURCH. In this card you can better see the elaborate detail of the church located on the southeast corner of Main and Seventh Streets. The steeple of the Episcopal Church of the Messiah is visible on the left. The congregation constructed a new church on North Santiago Avenue and moved there about 1960.

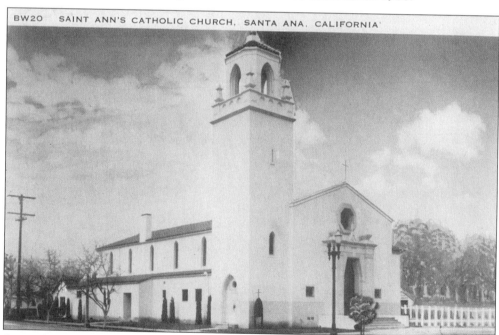

BW20 SAINT ANN'S CATHOLIC CHURCH, SANTA ANA, CALIFORNIA

SAINT ANN'S CATHOLIC CHURCH. Located at Borchard and South Main Street, this building was constructed in 1923 and remains essentially unchanged. A school and other buildings have been added to the original structure shown here.

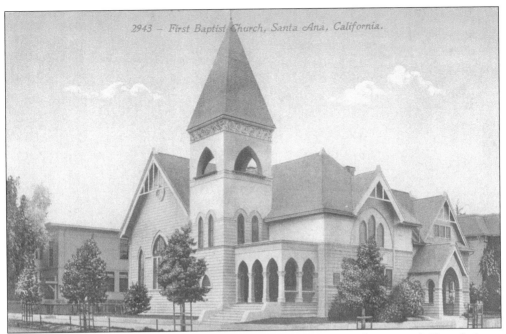

FIRST BAPTIST CHURCH. Built in 1876 at the northwest corner of Main and Church (now Eighth) Streets, the land for the First Baptist Church was donated by Santa Ana founder William Spurgeon.

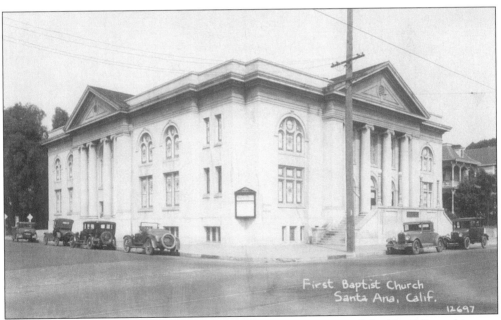

FIRST BAPTIST CHURCH. When the congregation outgrew its original building, this new structure was built in 1913–14 on the same site, in part because the land had been donated by the city's father, William Spurgeon. This church was designed by Frederick Eley and was built for $53,000 in 1914.

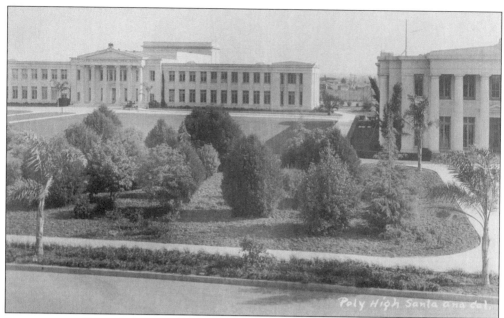

POLYTECHNIC HIGH SCHOOL. The pride of the Santa Ana educational establishment existed only from 1913 until the earthquake on March 10, 1933, which caused severe structural damage, resulting in the school's demolition. The site is now that of Santa Ana High School.

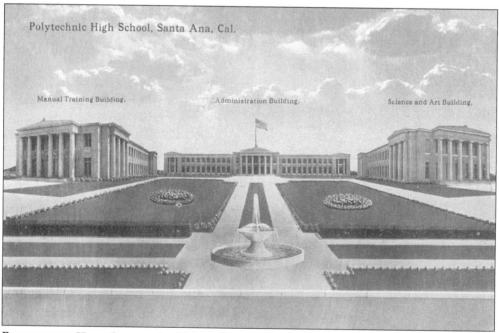

POLYTECHNIC HIGH SCHOOL (*c.* **1918**). Santa Ana Polytechnic High School was built in 1913 on a 23-acre parcel. The cost of construction was $250,000. In 1915, the school had an enrollment of 850 and a faculty of 40. One wing was devoted to the Santa Ana College, which was founded in 1915.

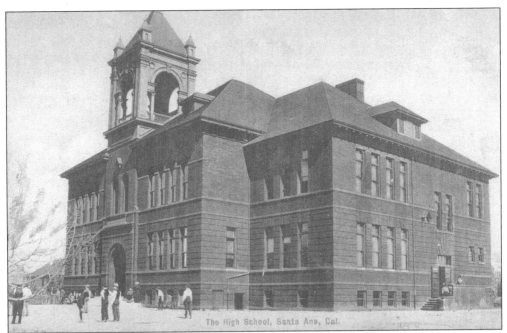

SANTA ANA HIGH SCHOOL. Looking similar to the county courthouse, this is actually the Santa Ana High School, located at Main and Tenth Streets from 1897 to 1912. The high school moved to the new building on the "outskirts of town" at 500 West Walnut Street in 1913. This building was then used as Willard Junior High School until 1931.

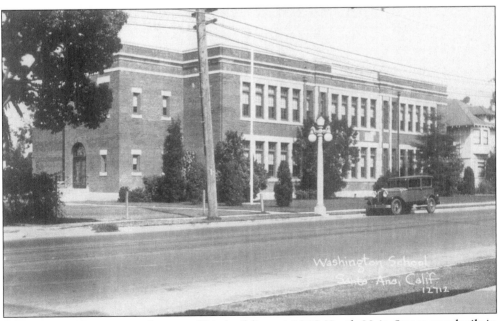

WASHINGTON ELEMENTARY SCHOOL. This building at 1012 North Main Street was built in 1922, one of the few Frederick Eley designs that was not a Spanish style. The school site was sold to C.J. Segerstrom and Sons and became the site for a United California Bank. Today this is the main building for the Orange County High School of the Arts.

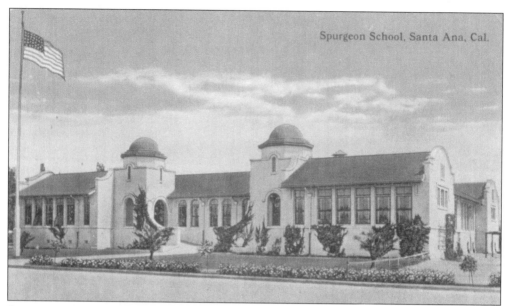

SPURGEON ELEMENTARY SCHOOL. Located at 210 West Cubbon Street, the school was constructed in 1912 and built by A.T. Sturges. Later additions were made in 1922. Following the 1933 earthquake, this building was torn down and replaced in 1934 by one designed by Frederick Eley. The school remains in use today as Franklin Elementary School.

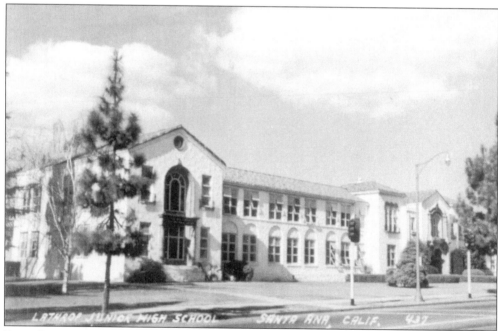

JULIA C. LATHROP JUNIOR HIGH SCHOOL. The school, located on Main Street just north of Russell, was designed by Frederick Eley and built in 1922. It was closed in 1966 and demolished a few years later to be replaced by another school building. The school was named after Julia Lathrop—the first woman to head an important U.S. government agency.

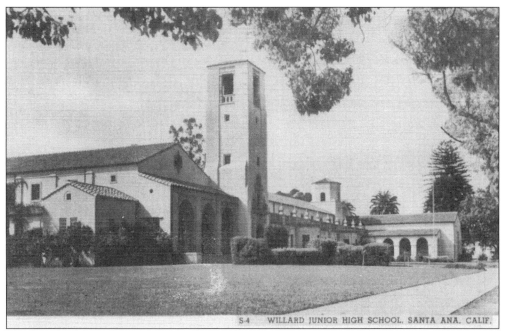

WILLARD JUNIOR HIGH SCHOOL. Willard Junior High was housed in this beautiful building on the block bounded by Washington, Parton, Ross, and Fifteenth Streets. This campus was built in 1931 on a former nursery site owned by George Ford. Following the February 1971 Sylmar earthquake, this building, along with numerous others in the Santa Ana school district, was torn down.

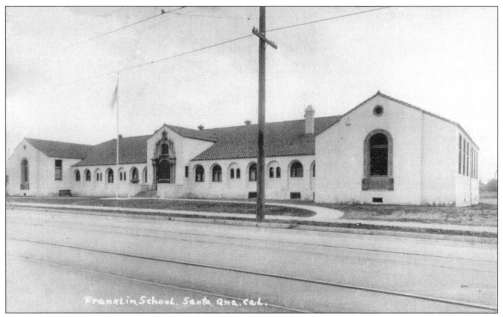

FRANKLIN ELEMENTARY SCHOOL. Franklin was located at 1512 West Fourth Street and designed by Frederick Eley. The building was demolished in 1971, and the site was vacated. Today it is the location of the Lydia Romero Cruz Elementary School.

81

JOHN MUIR ELEMENTARY SCHOOL. Located at 1322 East Fourth Street and built in 1922, the building was jointly designed by Frederick Eley and T.C. Kistner. The school was closed due to structural damage following the 1971 earthquake, and students were relocated to other district schools. The building was demolished the same year.

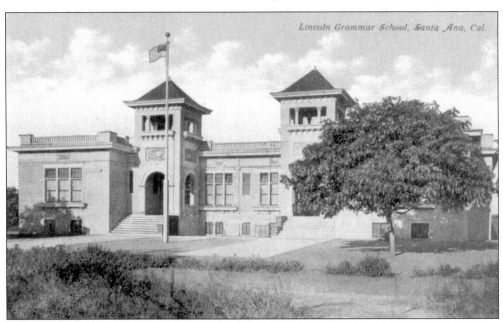

LINCOLN GRAMMAR SCHOOL. This elementary school was built in 1910 at the southeast corner of Fifteenth and French Streets. It was eventually converted to school district offices and later torn down in the early 1970s. The site is presently the location of the Wallace R. Davis Elementary School.

Five
THE GREAT
EARTHQUAKE OF 1933

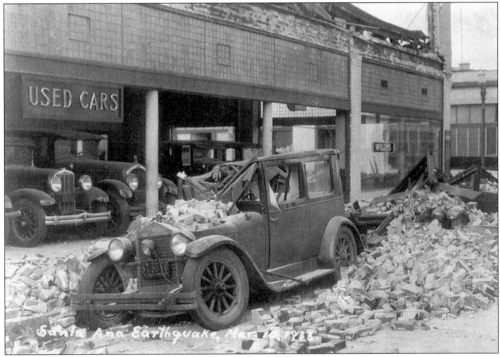

SANTA ANA, MARCH 10, 1933. The Long Beach Earthquake, measuring 6.3 on the Richter Scale, hit Southern California hard. In Santa Ana, three people died. In addition, the downtown business district sustained heavy damage, documented in this and the next few postcards. Many buildings had to be razed due to structural damage. This picture shows a building probably near Fifth Street at Spurgeon.

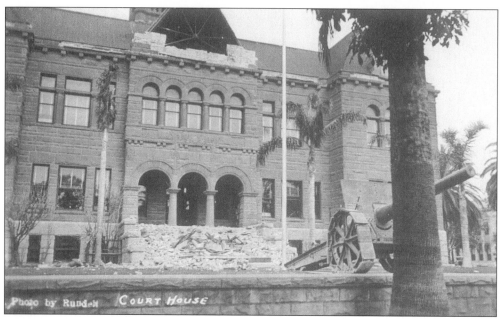

ORANGE COUNTY COURTHOUSE. Damage to the courthouse due to the quake included the gables over the main entrance. They were never replaced.

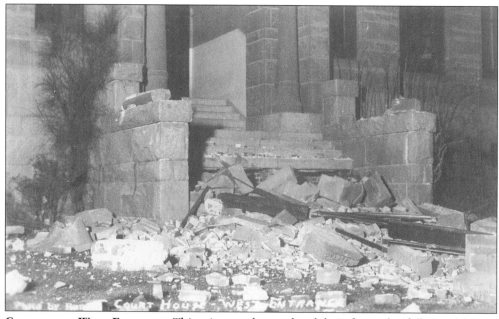

COURTHOUSE WEST ENTRANCE. This picture shows the debris from the fallen gables on the Broadway side of the courthouse.

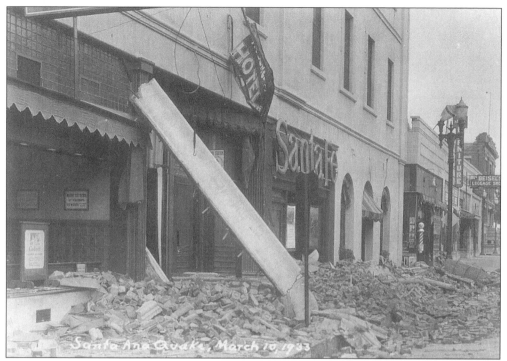

ROSSMORE HOTEL. This view shows the Sycamore Street frontage of the Rossmore Hotel following the earthquake. Two of the three deaths in Santa Ana occurred here; reportedly, a newly-married couple visiting from Oakland were killed as they ran outside into the path of falling bricks.

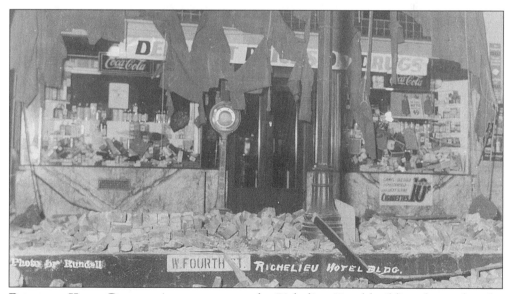

RICHELIEU HOTEL DAMAGE. As you can see, the Richelieu Hotel building, located at the northeast corner of Fourth and Ross Streets, received serious damage from the earthquake. More importantly though, and quite sad, was that one of the three fatalities happened here.

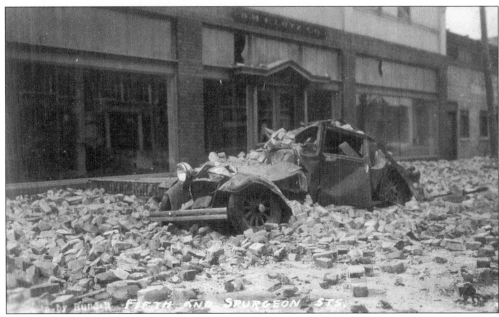

FIFTH AND SPURGEON STREETS. The Lutz Building, a farm implement business, sustained considerable damage when the earthquake struck at 5:54 p.m. on March 10, 1933. It appears that further damage occurred in an aftershock; see the bottom photo of this page.

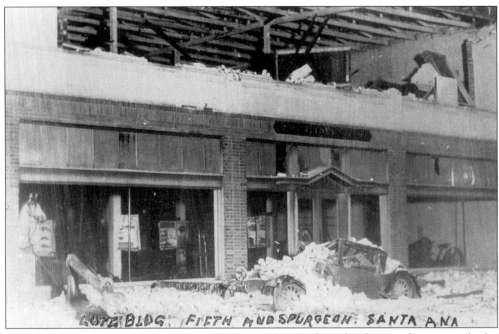

LUTZ BUILDING, FIFTH AND SPURGEON. The extensive earthquake damage here reveals the wooden roof trusses and other construction materials and techniques of the day.

Six

RESIDENTIAL AREAS
AND PARKS

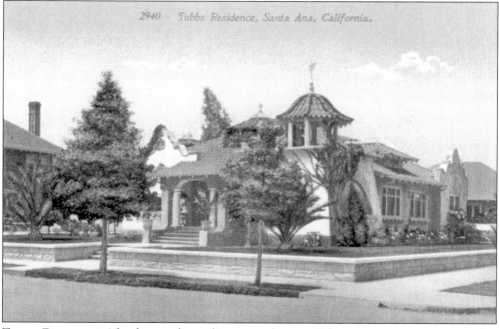

TUBBS RESIDENCE. The benevolent climate and active lifestyle of the community led builders to create unique homes that included a variety of architectural styles such as this one, *c*. 1910, the home of a tax collector which was located at the southwest corner of Ninth and Spurgeon Streets. Its contemporary, the Wehrly Home, still stands across the street at 819 North Spurgeon. These are only a few of the stately homes that made this area, now known as Historic French Park, the "Nob Hill" of Santa Ana in the early 1900s. In 1997, the neighborhood was placed on the National Register of Historic Places, protecting all remaining historic homes whose occupants still value the character of their homes and the close proximity to the civic and business district.

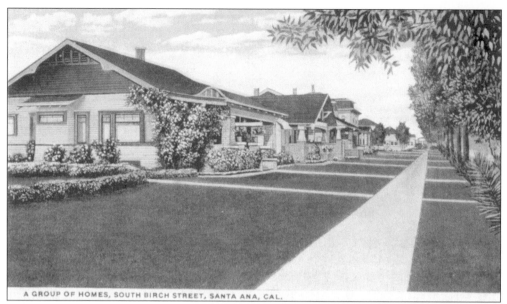

A GROUP OF HOMES, SOUTH BIRCH STREET, SANTA ANA, CAL.

SOUTH BIRCH HOMES. These homes are located in the Historic Heninger Park neighborhood on the 600 block of South Birch Street. The group includes three Craftsman Bungalows: the Hilton House built in 1914, the Angell House built in 1912, and the Chapman House built in 1909. Just beyond that you find the Heninger House built by Martin and Mary Heninger in 1911. Heninger was the developer of many homes in that neighborhood.

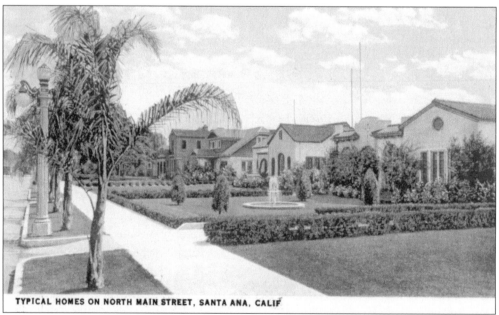

TYPICAL HOMES ON NORTH MAIN STREET, SANTA ANA, CALIF

NORTH MAIN HOMES. These houses are typical of the size and style you would find on North Main around the 1920s. As Main Street/Highway 101 became a more popular traveling route, residences were removed, and commercial buildings and storefronts took their place.

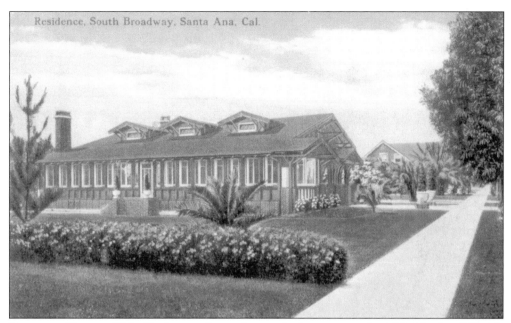

POMEROY HOUSE. This Craftsman-Bungalow-style house on the 700 block of South Broadway was built in 1912, and is listed on Santa Ana's Register of Historic Properties. Edward and Mary Pomeroy were the first owners of this Swiss-influenced bungalow, and lived there with their three children. The exterior structural members of the home are very unusual and mark this house as a rare example of this sub-style.

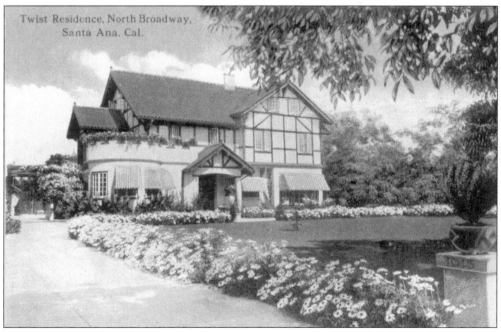

TWIST RESIDENCE. This beautiful house is located at Tenth and Broadway. It was owned at one time by Dr. Jesse Manning Burlew and eventually became the Basler Convalescent Care Home.

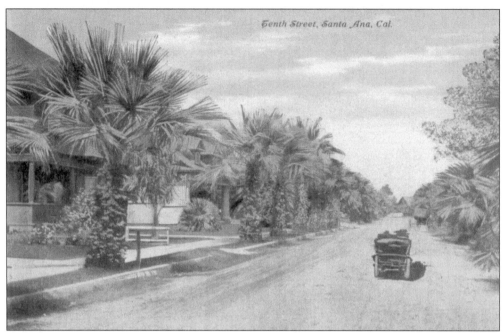

TENTH STREET. This is a view of Tenth Street, probably east of Bush, *c.* 1905.

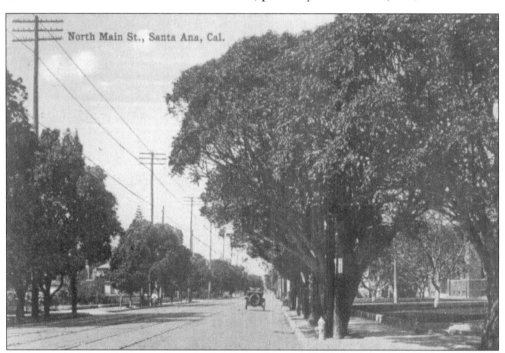

NORTH MAIN STREET. Put yourself in this picture, walking north on Main from about Ninth Street, *c.* 1910. At any moment a red car might pass you on the Pacific Electric tracks that ran to Orange. Or you might encounter a student enroute to Santa Ana High School, just visible on the right. After the new Polytechnic High School was completed in 1913, the original Santa Ana High School shown here became Willard Junior High.

ACACIA TREES, BUSH STREET. Pictured above is another example of the variety and density of lush vegetation early residents enjoyed. No wonder they left the gray skies, barren trees and bone-chilling temperatures of other areas for the balmy temperatures of Southern California.

BUSH STREET. Wide, clean, uncluttered dirt roads seem appealing in this early view where houses peek out from an urban forest.

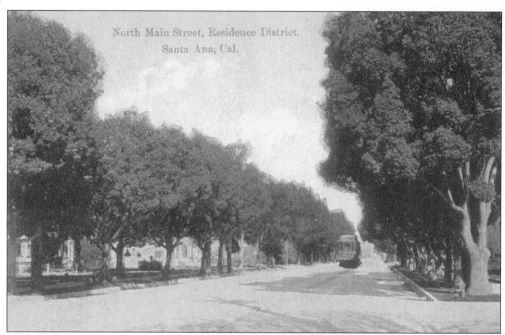

NORTH MAIN STREET. Two Pacific Electric lines radiated from downtown Santa Ana. Those who took an electric car, like the one shown here heading north to Orange through the residential neighborhood of North Main, enjoyed a scenic and peaceful ride—quite a contrast to the experience today!

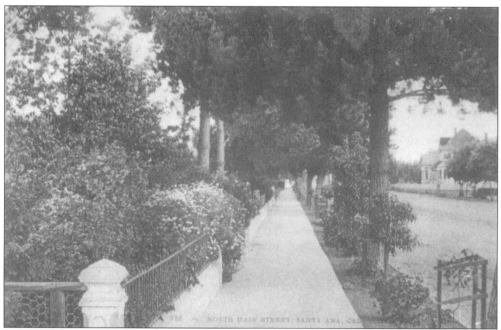

NORTH MAIN STREET. Wide sidewalks and beautifully landscaped homes invited residents to enjoy leisurely strolls through neighborhoods such as this one shown on North Main Street *c.* 1915.

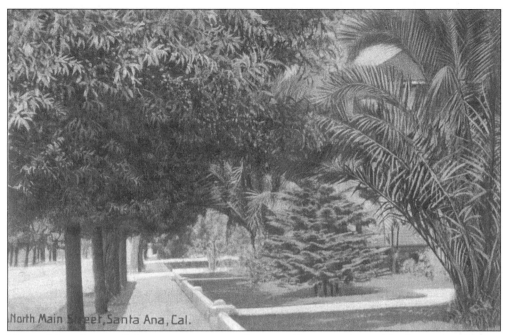

NORTH MAIN STREET. Palms, evergreens, and a magnificent tree provide dramatic evidence that almost anything—and everything—grows in this sunny climate. By driving north along this route, you would be following a major path to the cities of Orange and Anaheim.

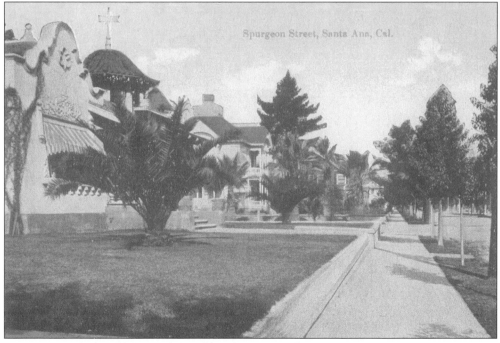

SPURGEON STREET. This view from the left corner of the Tubbs Home at the southwest corner of Ninth and Spurgeon looking north to the C.E. French mansion gives another glimpse into the city's rich residential heritage.

93

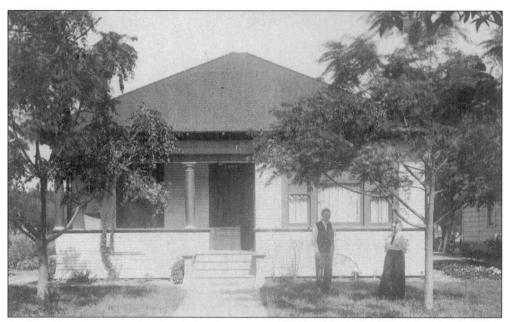

MYSTERY HOUSE. If pictures could talk Why did someone make a photo postcard of this relatively average-looking house located somewhere in Santa Ana, *c.* 1910? Are the people in the picture parents, grandparents, cousins? Was this to send back east to show how well the family was doing out here in the "wild, wild west?" If you know, please contact the author and help solve the mystery.

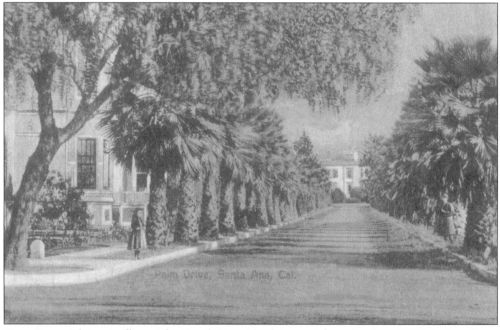

PALM DRIVE. This actually may be Tenth Street looking east from Bush, *c.* 1905. In Southern California, landscaping included native oaks and palms side-by-side as shown here.

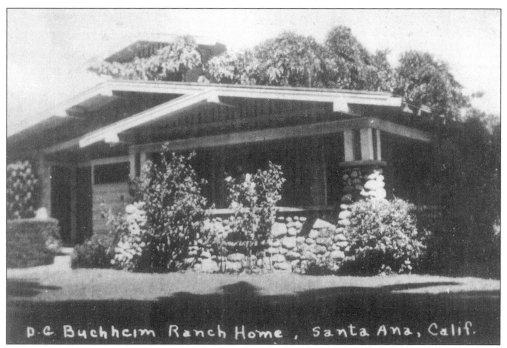

D.C. Buchheim Ranch Home, Santa Ana, Calif.

D.C. Buchheim Ranch House. Here is a very pretty Craftsman-style home from about 1920. Right after WW I, there was a housing boom in Santa Ana, and orchards and farms surrounding downtown became residential areas. A great many of these homes survive to this day, adding to the unique character of the city.

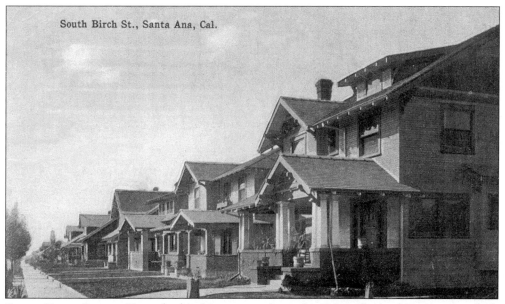

South Birch St., Santa Ana, Cal.

South Birch Street. Note the hitching posts along the sidewalks in this picture, which shows larger example of Craftsman Bungalow-style homes located on the west side of Birch, south of First Street in the Historic Heninger Park neighborhood. This is now the eastern portion of the school yard for Heninger Elementary School, built in 1990.

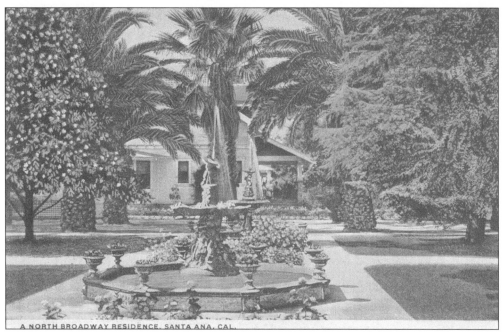

NORTH BROADWAY HOME. This view shows a well-manicured lawn with a picturesque fountain in the north part of town, *c.* 1920

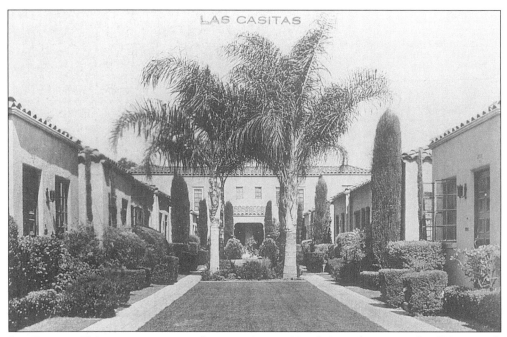

LAS CASITAS. This apartment complex remains on North Broadway, north of Twentieth Street. Las Casitas looks about the same and is as well-maintained as when the photo was taken—a true credit to the owners for keeping property up so well.

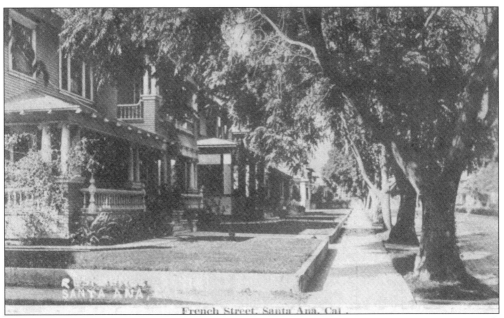

FRENCH STREET RESIDENTIAL. This view shows tree-lined French Street looking north probably from a location near Sixth Street. The card dates back to about 1910–1915, when many of Santa Ana's wealthiest families lived in this neighborhood; you can sense that by just looking at the large, two-story houses with extensive detail work.

TENTH STREET RESIDENTIAL. This residential neighborhood is likely to be Tenth Street, east of Bush. The houses are a variety of Colonial Revival and Craftsman styles. The date is 1910.

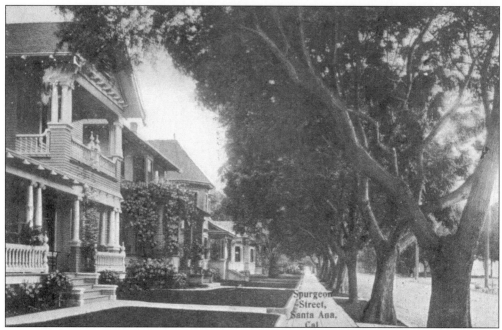

SPURGEON STREET RESIDENTIAL. Here are still more pictures of this very beautiful neighborhood at the turn of the century. Today, this area is known as Historic French Park—a designation won by residents who appreciate the history and beauty of the area they live in.

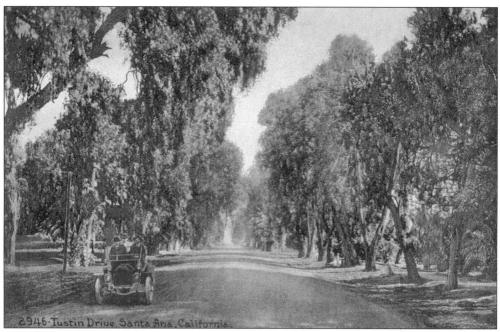

TUSTIN DRIVE. It looks like a family was out for a Sunday drive in the "rural" part of town—Tustin Drive, *c.* 1905–1910.

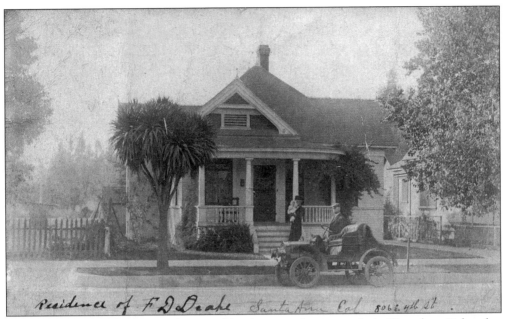

Residence of F.D.Drake Santa Ana Cal 806 E 4th St.

HOME OF F.D. DRAKE. F.D. Drake sent this photo card to a cousin in Waterloo, Nebraska, in 1911. The house on East Fourth Street is still standing.

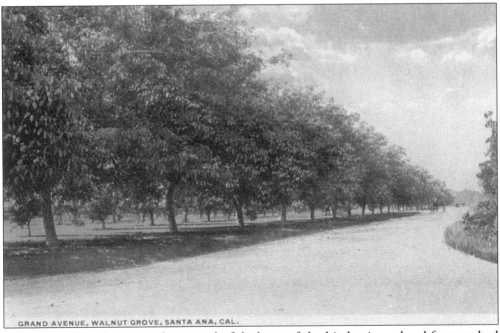

GRAND AVENUE, WALNUT GROVE, SANTA ANA, CAL.

WALNUT GROVE. This is another wonderful photo of the big business local farmers had growing walnuts, this time on Grand Avenue. Except for a few random trees that still survive in backyards, the walnut groves were replaced with homes for the fast-expanding Santa Ana population or, in some cases, with commercial and industrial buildings.

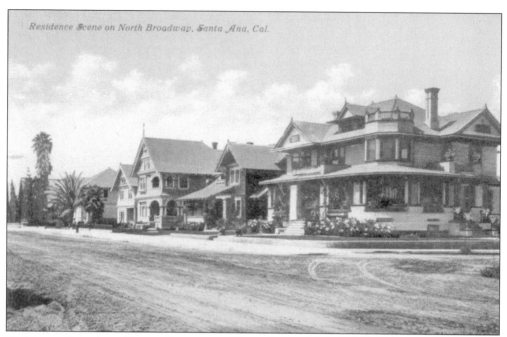

RESIDENCE SCENE ON NORTH BROADWAY. These beautiful homes were originally located on the southwest corner of Eighth Street (now Civic Center Drive) and Broadway. They were replaced by office buildings for the County of Orange in 1954.

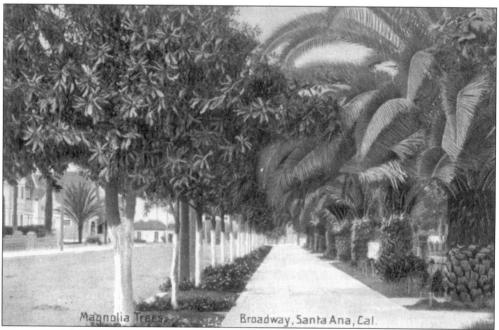

MAGNOLIA TREES. Santa Ana has always had trees and plants lining its streets, but probably not as lush as back in the time of this card. The *c.* 1915 view is of Broadway, north of Sixth Street, on the perimeter of the courthouse block.

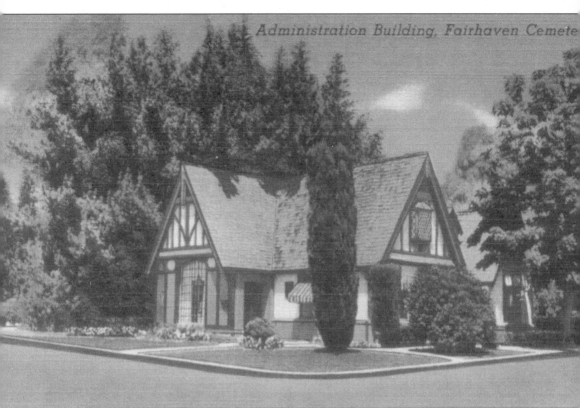

FAIRHAVEN CEMETERY. Fairhaven Memorial Park and Mortuary was established in 1911, in part to serve the well-to-do growers and businessmen of Orange County. However, you can find tombstones with dates as early as 1875, as many families had their loved ones disinterred and moved to Fairhaven. The cemetery is well known as the last resting place of Civil War leaders (both sides). This Tudor-style house was built in the 1920s and used for sales and records. Originally the sales office was located in the downtown area—miles away from the "remotely located" cemetery. Fairhaven has a beautiful mausoleum, built in 1916, constructed of granite with 32 different kinds of marble and stone on the inlaid floors and walls. Located next to Fairhaven is the Santa Ana Cemetery, operated by the County of Orange. This cemetery was begun in 1870, and was originally in the Civic Center area near Fourth and Ross. It was moved in 1875 to the large, approximately 100-acre parcel called the Cemetery District, in order to allow the city to expand without having a cemetery in the midst of the business district. All of the people buried in town were moved to the new location. Fairhaven Memorial Park eventually purchased about two-thirds of the district property. Other small parcels were purchased for the use of the Masons and Odd Fellows, as well as for church cemeteries by St. John's Lutheran Church of Orange and Old Evangelical Lutheran Church.

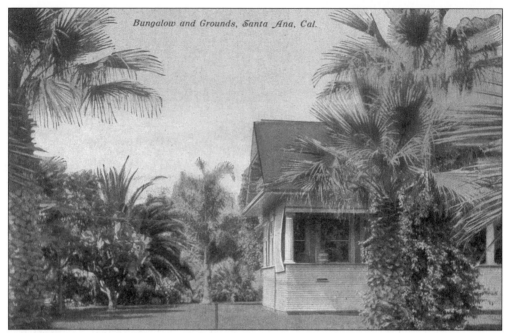

BUNGALOW AND GROUNDS. This architectural style, popularized by Greene and Greene architects in Los Angeles County (especially Pasadena), was also embraced in Santa Ana as residents enjoyed a lifestyle influenced by the warm, sunny climate.

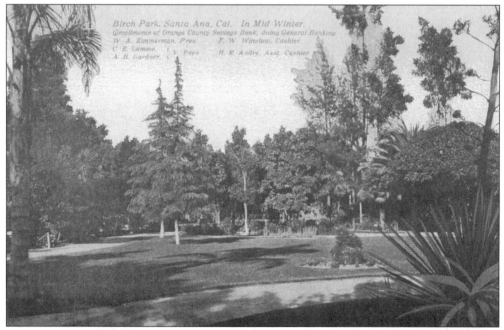

BIRCH PARK IN MID-WINTER. This card, "Compliments of Orange County Savings Bank," provides an attractive backdrop for the names of its officers—an important feature when residents and bankers knew each other by name.

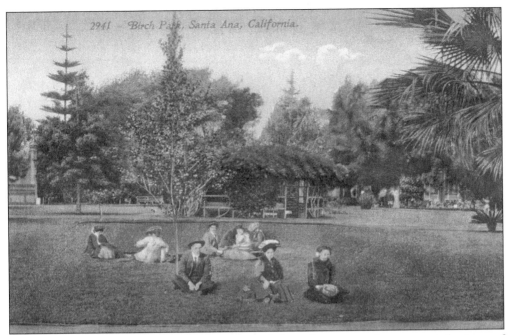

BIRCH PARK. A day in the park required formal dress for men and women at the turn of the century, as shown in this *c.* 1905 photo.

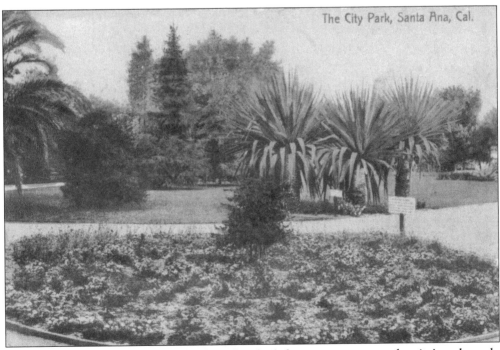

THE CITY PARK. This probably is Birch Park, which for many years was the city's only park.

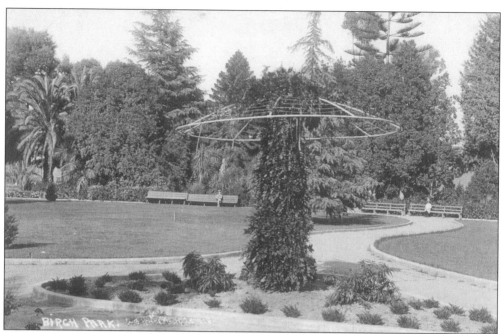

BIRCH PARK. The land for this park was donated by the son and namesake of A.W. Birch, Esq., a wealthy farmer who came to California in 1873 from Cuba, Illinois, for his health. It was part of an additional tract of land he purchased from First to Sixth Streets and from West to Ross Streets. Birch Street also bears his name.

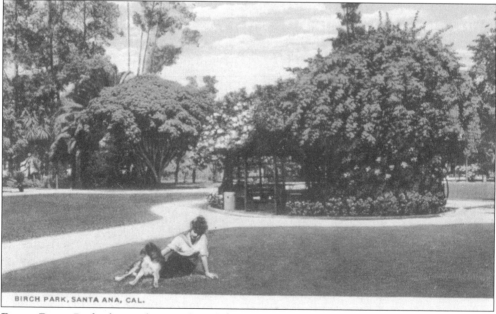

BIRCH PARK. Parks have always played an important role in the lives of residents and their pets, giving them the perfect place to get a bit of exercise on a beautiful day—and the opportunity to mingle with like-minded neighbors. The coiffure and clothing date this scene *c.* 1915.

104

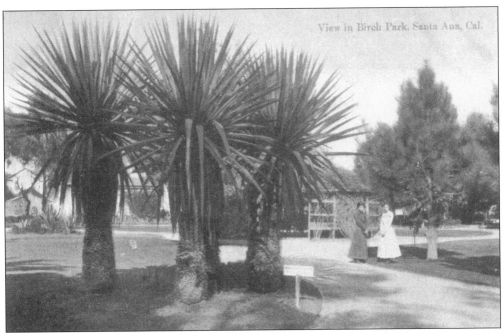

VIEW IN BIRCH PARK. Although most homes had telephones, operated through a central switchboard, casual encounters on walks such as this were still were a central part of one's social life.

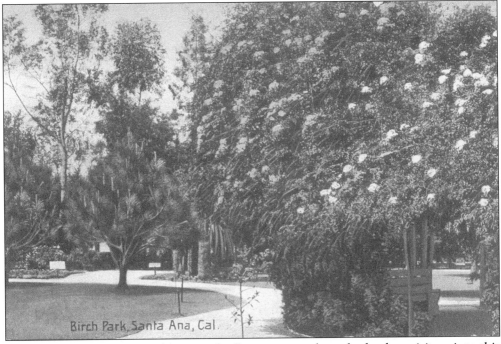

BIRCH PARK. Serpentine pathways and a flower-covered gazebo beckon visitors into this urban Shangri-La. Unfortunately, the descriptive plaques no longer exist, and the landscape has changed dramatically since this photo was taken.

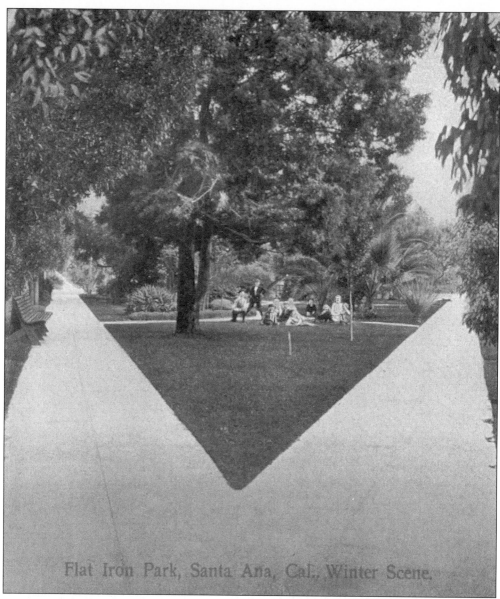

Flat Iron Park, Santa Ana, Cal., Winter Scene.

FLAT IRON PARK (WINTER). Flat Iron Park was the original name for a triangle-shaped park (renamed French Park in the 1970s) bordered by French, Minter, and Vance Streets. The surrounding neighborhood is one of the oldest in the city and was home to some very large and stylish homes at the turn of the century. One such home, a Queen Anne Victorian that occupied almost half a city block, belonged to Charles Edwin and Emma French. The house was demolished in the late 1960s for a parking lot. Other magnificent houses in the neighborhood were also razed for urban renewal and redevelopment reasons. Neighbors banded together in the 1980s to form the Historic French Park Neighborhood Association. In 1997, the neighborhood was placed on the National Register of Historic Places—an honor for its history and a monument to the efforts of residents working together to preserve their neighborhood and their past. This card dates to about 1910.

106

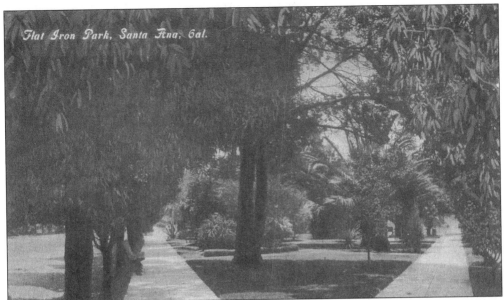

FLAT IRON PARK (SUMMER). This picture is from a later date than the one on the opposite page, as you can tell by the more mature growth of some of the foliage. The park is home to neighborhood gatherings and an occasional jazz festival. It is the centerpoint to the Historic French Park neighborhood and renamed for local businessman Charles French.

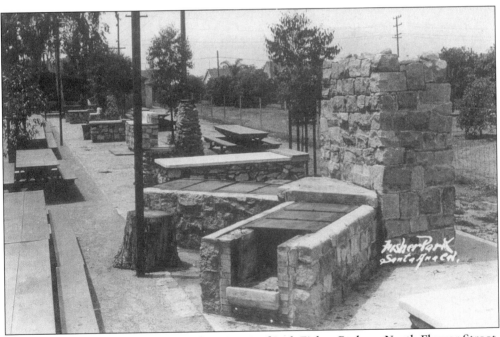

JACK FISHER PARK. This image is a 1930s view of Jack Fisher Park on North Flower Street. The park was named to honor the courageous local WW I hero who died in 1929. He received several medals during the war, including a Purple Heart and the Medaille Militaire—France's highest military decoration. Fisher later became an artist for the Santa Ana *Register*.

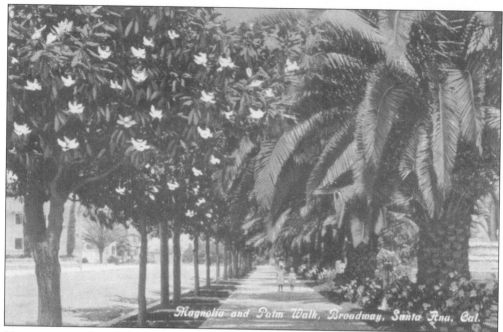

MAGNOLIA AND PALM WALK, BROADWAY. This wide, gracious walk immediately west of the county courthouse undoubtedly lured residents and members of the legal community alike to take advantage of the level terrain and temperate climate.

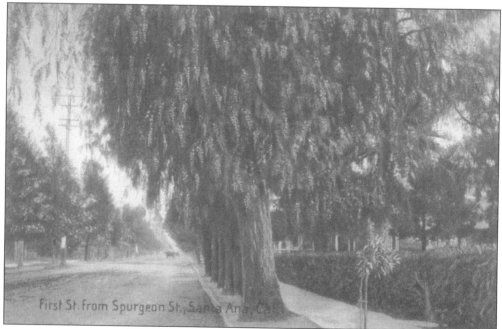

FIRST STREET FROM SPURGEON STREET. Mature landscaping was a valued asset in the early days of the 20th century, and it was featured in postcards such as this one to show the charming ambiance of this bustling city.

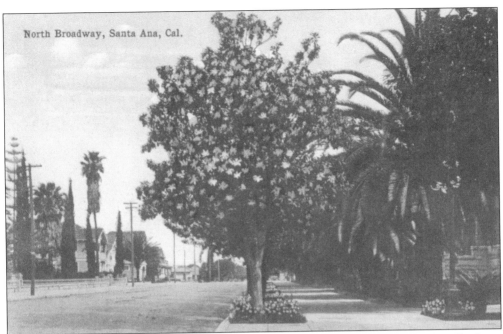

North Broadway, Santa Ana, Cal.

NORTH BROADWAY. This is another view of magnolias and palms lining a sidewalk along North Broadway.

North Broadway Residence, Santa Ana, Cal.

W.W. HALESWORTH HOME. The house hidden behind the palms was known as the "house of 100,000 bricks." Halesworth was the best friend of Albert Birch, and they were in business together in Cuba, Illinois. Halesworth planted all the palms on the property himself. Eventually the home was torn down, and the Seventh Day Adventist Church is located there today. Many of the palms still remain. Halesworth Street is named for him.

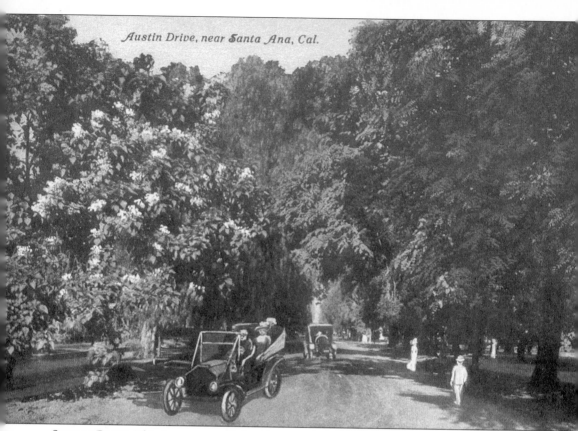

Austin Drive, near Santa Ana, Cal.

SUNDAY DRIVE. This is a postcard showing residents taking a leisurely drive down scenic Tustin Drive during the early part of the 20th century. Today the road (now Tustin Avenue) is a busy commercial thoroughfare. Then, it was a quiet, tree-lined drive with a dirt road surface. The "Austin" (instead of Tustin) is a typographical error on the card.

Seven
ODDS AND ENDS

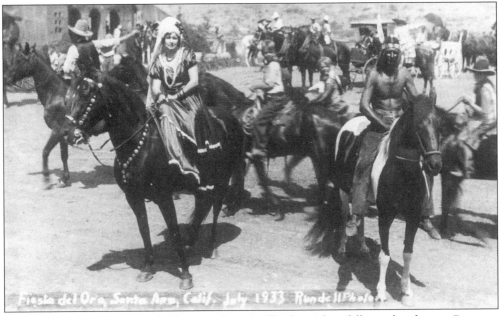

FIESTA DEL ORO (1933). Lela Thomas Deardorff rides sidesaddle on her horse, Rena, at the Fiesta del Oro celebration. Lela's dress was red satin with silver lace trim, from what we are told. Gene Thomas on the right is costumed as an Indian. The celebration was launched with a street breakfast on North Main between Fourth and Fifth Streets on July 27, 1933. The Queen of the Fiesta was Margaret Sawyer.

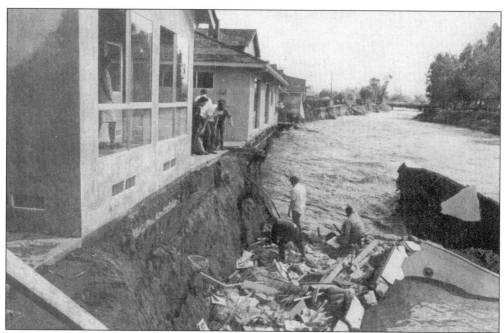

FLOODING. These homes on River Lane, west of Bristol Street, lost their backyards during severe rain storms in February of 1969.

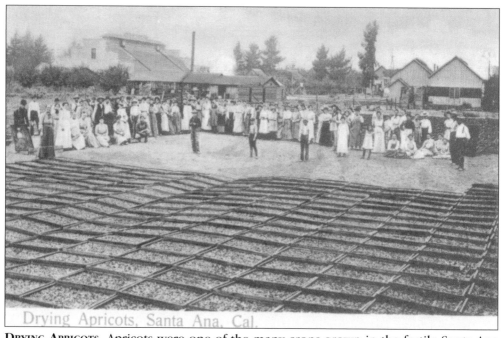

Drying Apricots, Santa Ana, Cal.

DRYING APRICOTS. Apricots were one of the many crops grown in the fertile Santa Ana Valley region. This card dates to about 1905.

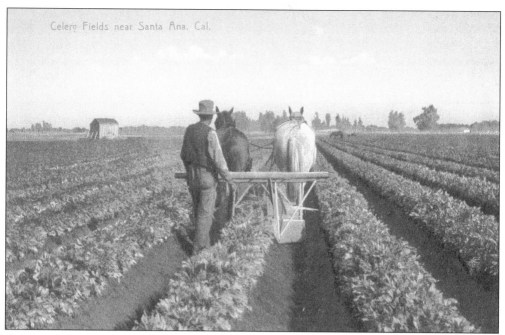

CELERY FIELDS. Celery was another agricultural product grown in the fertile Santa Ana Valley.

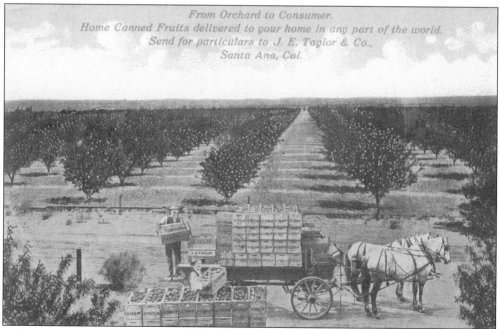

J.E. TAYLOR CANNING COMPANY. Fred and Elizabeth Taylor moved to Santa Ana in 1885 and started a small fruit ranch on East Fourth Street. They started to can peaches and apricots, and send them to other parts of the country. Eventually, their product was shipped worldwide. In the 1930s, the Taylors sold the company, and it became Case-Swayne Foods.

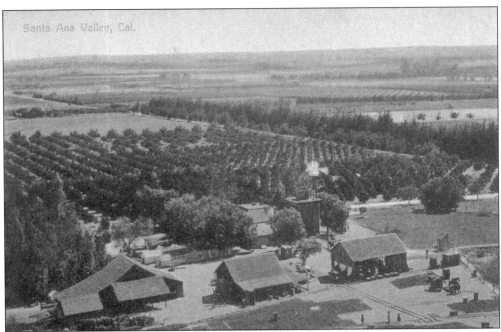

THE SANTA ANA FARMING VALLEY. This card dates back to about 1910, when farming was a major business for local residents. The photo was probably taken from the area now known as Santa Ana Heights.

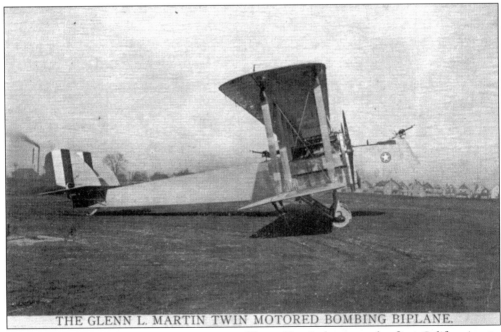

THE GLENN L. MARTIN TWIN MOTORED BOMBING BIPLANE.

GLENN MARTIN. In 1909, aviation pioneer Glenn Martin became the first Californian to fly. Martin's career started in Santa Ana, constructing planes in a former church building. The bombing biplane pictured above was built by Martin Aviation, probably at his East Coast factory sometime after WW I.

114

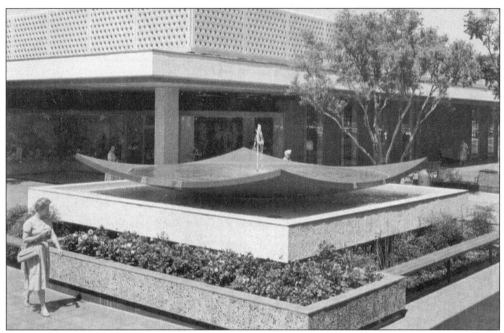

FASHION SQUARE FOUNTAIN. This fountain was located in the heart of the Fashion Square Shopping Center on North Main, built in 1959. The fountain was removed when the center remodeled and expanded to become Main Place Santa Ana in September 1987.

You may talk about your "beautiful snow"
And write "the weather's fine"
But we don't spend all our money on coal,
SANTA ANA, CAL., for MINE,

NO SNOW HERE! The weather in Santa Ana is pretty typical of Southern California—warm and pleasant. Coal? How many readers remember shoveling coal into your furnaces?

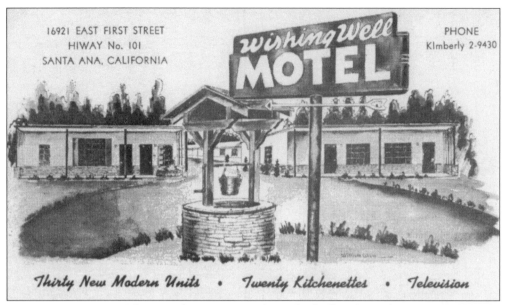

16921 EAST FIRST STREET
HIWAY No. 101
SANTA ANA, CALIFORNIA

Wishing Well
MOTEL

PHONE
KImberly 2-9430

Thirty New Modern Units • Twenty Kitchenettes • Television

WISHING WELL MOTEL. This motel is gone now, but it had offered comfort to many a weary family traveling along Highway 101, the main arterial between San Diego and Los Angeles, until the 5 Freeway was extended through Santa Ana and to points south. The modern motel included features like in-room telephones, air conditioning, and televisions.

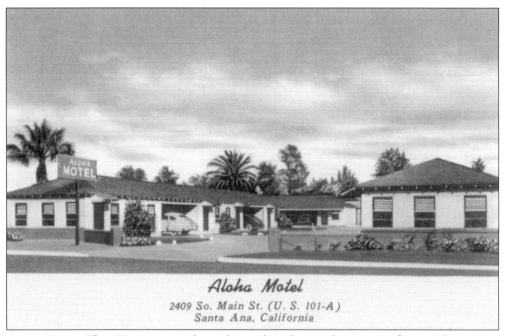

Aloha Motel
2409 So. Main St. (U. S. 101-A)
Santa Ana, California

ALOHA MOTEL. This 22-room motel was located in the southern part of town along Main Street for those travelers who were headed towards Newport Beach. The motel had garages with each unit and proudly noted their glass-door showers. Located nearby was an old sugar factory and a Sears store. The Aloha is still in use today.

116

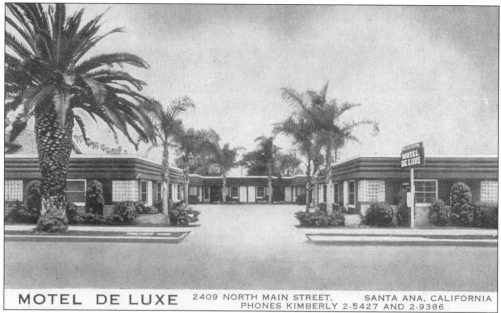

MOTEL DE LUXE 2409 NORTH MAIN STREET, SANTA ANA, CALIFORNIA
PHONES KIMBERLY 2-5427 AND 2-9386

MOTEL DE LUXE. According to the card, the Motel De Luxe (later known as the English Motel) was an ultra-modern, 15-unit motel with first-class kitchenettes, tiled showers, and 21-inch TVs. Owner/managers were Harold, Velma, and Loretta English. The motel was torn down in the early 1990s for the widening of the Santa Ana Freeway.

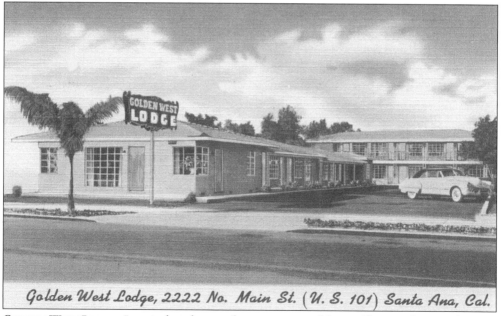

Golden West Lodge, 2222 No. Main St. (U. S. 101) Santa Ana, Cal.

GOLDEN WEST LODGE. Located at the southwest corner of Santa Clara and Main, this was a "new 21 unit, nicely furnished motel with tile baths, tubs, or showers." The motel had Panelray heat, radios, and wall-to-wall carpeting. Rooms were $9 a day in 1959.

117

HOMETOWN POSTCARD. This is one of a series of preprinted cards with changeable felt locales.

NOW, JUST WHAT DID THEY MEAN? This is an odd card that dates to the 1940s or so.

SANTA ANA DUTCH GIRL. Did she really walk down Fourth Street in wooden shoes, or was she just kidding us?

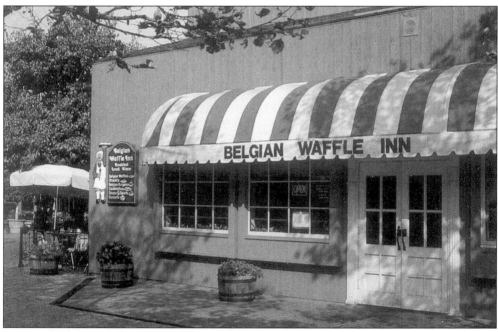

BELGIAN WAFFLE INN (*c.* 1980). Pictured above is a wonderful restaurant located in the South Coast Plaza Village that had the greatest-tasting waffle, strawberries, and whipped cream combo in the universe. This author has never truly recovered from its closing. Today, the Village continues to be an eclectic combination of unique stores and excellent restaurants.

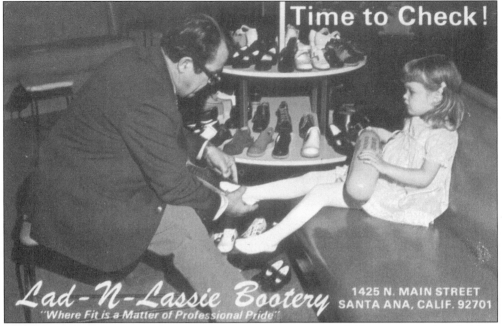

OLD-FASHIONED SERVICE. Lad-N-Lassie Bootery was a successful business on North Main Street in the 1970s. Don't you just wonder what happened to the little girl in this picture? Today, is she a doctor, businesswoman, terrific mom, or maybe a little of each?

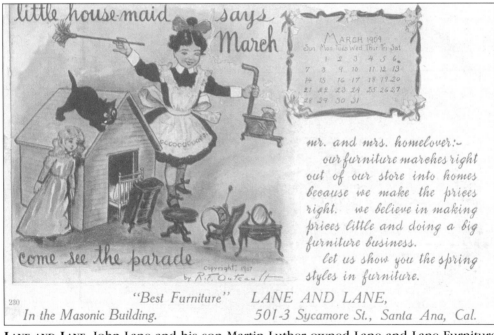

LANE AND LANE. John Lane and his son Martin Luther owned Lane and Lane Furniture located on the first floor of the original Masonic Temple building on Sycamore Street. This cute card is from March of 1909.

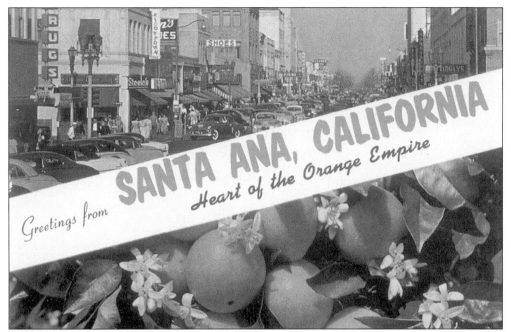

GREETINGS! This format (and the oranges) can be seen used by other cities, but the picture of the top is definitely Fourth Street looking east from Main.

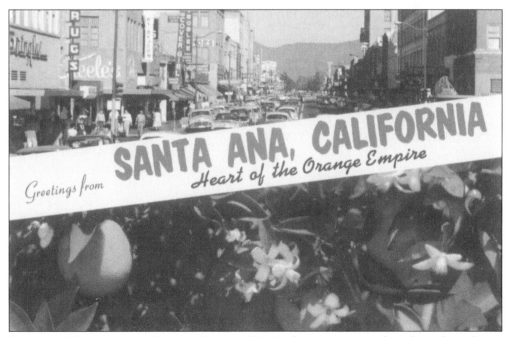

FROM THE HEART OF THE ORANGE EMPIRE. This is the same type of card as above but a slightly later view of Fourth Street. Notice the cars and the larger *Steele's* sign.

GREETINGS FROM
SANTA ANA, CALIFORNIA

A132

YEEHA! Thanks for dropping by and looking at the cards. See you again real soon!

BIBLIOGRAPHY

Ball, Dr. C.D.; McPherson, William; Stephenson, T.E.; eds. *Orange County History Series, Volume 1*; Orange County Historical Society, 1931; reprinted 1968.

Ball, Guy, ed. *A Victorian Reclaimed: Pre-Restoration Images of the Dr. Howe-Waffle House*. Hand colored images by Yolanda Morelos Alvarez. Santa Ana Historical Preservation Society, 1998.

Blamer, Clarice; Brigandi, Phil; Cramer, Esther; Dixon, Keith; Marsh, Diann; eds. *A Hundred Years of Yesterdays: A Centennial History of the People of Orange County and Their Communities*. Orange County Centennial, 1988.

Goddard, Allen and Francelia. *Santa Ana's 100 Years*. Century I Historians; 1969.

Hallan-Gibson, Pamela. *The Golden Promise: An Illustrated History of Orange Count*. Windsor Publications; 1986.

History of Santa Ana City and Valley; original publication of 1887 reproduced by Paragon Agency; 1999.

Les, Kathleen. *Santa Ana's Architectural Heritage*. Santa Ana Historic Survey; 1980.

Loewnau, Doris. *Episcopal Church of the Messiah*. Published by the Episcopal Church of the Messiah in honor of their 100th anniversary, 1989.

MacArthur, Mildred Yorba; Meadows, Don; Rita, Ryan; Talbert, Thomas; eds. *The Historical Volume and Reference Works: Covering Garden Grove, Santa Ana, Tustin*. Historical Publishers, 1963.

Marsh, Diann. *Santa Ana: An Illustrated History*. Heritage Publishing; 1994

Rediscovering Historic Downtown Santa Ana; a walking-tour guide published by the Santa Ana Historical Preservation Society; 2000.

Richardson, Robert. *Orange County's Pioneer Architect: Fredrick Eley*. Santa Ana Historical Preservation Society; 2000.

The Santa Ana Afghan: Celebrating the Unique Historic Buildings of Santa Ana, California; Diann Marsh; a booklet from the Santa Ana Historical Preservation Society; 1997.

Sleeper, Jim. *Orange County Almanac of Historical Oddities*. Ocusa Press; multiple editions, 3rd edition dated 1986.

———. *Turn the Rascals Out: the Life and Times of Orange County's Fighting Editor, Dan M. Baker*. California Classics; 1973.

Sorenson, John. *The Orange Blossoms, 50 Years of Growth in Orange County*. Heritage Publishing; 2000.

Swanner, Charles D. *Santa Ana: A Narrative of Yesterday*. Saunders Press; 1953.

———. *The Story of Company L, Santa Ana's Own*. Fraser Press; 1958.

Taylor, Richard, ed. *A Century of Memories, 1873–1973*. Published by the First United Methodist Church in honor of their 100th anniversary, 1973.

Wheeler, Roy. *A Century of Reflection*. Published by Santa Ana Lodge 241 F.& A.M. in honor of their 100th anniversary, 1975.

For more information on Santa Ana history , visit the Santa Ana Historical Preservation Society's website at: http://www.SantaAnaHistory.com

ACKNOWLEDGMENTS

The author wants to give credit to all of the photographers, artists, businesses, churches, and postcard publishers whose cards are reprinted in this book. Without their efforts, we would not be able to reflect upon the past in this way. For that we are eternally grateful.

Allen & Miller Architects, Aloha Motel, Amescolor Publishers, Belgian Waffle Inn, Benham Company, Ann Berkery, Bowers Museum, Madison Burden, Don Bush, Carlin Post Card Company, Cary's of Santa Ana, Douglas Caulkins, E.P. Charlton and Co., Edward Cochems, F.J. Coles, Colourpictures, H.S. Crocker Company, C.T. American Art, Donevon Studios, Ellis and Sawyer, English Motel, Fairhaven Memorial Park, Friends of the Santa Ana Public Library, Allen and Francelia Goddard, Golden West Color Card Company, Golden West Lodge, Justin Hill, Hotel Santa Ana, M.L. Keeler, Kenrok Press, Kono Hawaii, Lad-N-Lassie Bootery, Lane and Lane, Rene Laursen, Ken Lee, G. Frank Leedy, Locantore, Longshaw Card Company, Los Angeles Chamber of Commerce, Merigold Brothers, Edward H. Mitchell, Mitock and Sons, B.R. Montgomery, Motel DeLuxe, Mr. Ivie Studio, Nationwide Advertising, Newman Post Card Company, Orange County Savings and Trust Company, Mike Roberts Studios, M. Rieder, Samanaya and Von Kensel, Santa Ana Chamber of Commerce, Santa Ana Historical Preservation Society, Santa Ana Hotel, Ferris H. Scott, Elmo M. Sellers, E. Severance & Company, Smart Set Studios, D. Edson Smith, St. Ann's Inn, Frank J. Thomas, Tichnor Quality Views, Leo Tiede, von Barneveld Advertising, George E. Watson, Western Publishing and Novelty Company, Western Resort Publications, F.W. Wiesseman, Wishing Well Motel, and Woods Company.

Many of the cards in this book were *photo postcards* published in smaller quantities and unmarked as to authorship. We don't want to ignore all those who played a part in these less-common cards with images that, at times, are almost personal in nature. Thank you!

No. 10—GIANT PEPPER TREE, SANTA ANA, ORANGE CO., CAL.

GIANT PEPPER TREE (*c*. **1906**). Location unknown, but from the buildings in the background, it looks close to the downtown area.

INDEX